John Berger

The Shape of a Pocket

John Berger was born in London in 1926. His many books, innovative in form and far-reaching in their historical and political insight, include the Booker Prize–winning novel *G*. John Berger now lives and works in a small village in the French Alps.

VINTAGE

INTERNATIONAL

The Shape of a Pocket

The Shape of a Pocket

John Berger

VINTAGE INTERNATIONAL · VINTAGE BOOKS
A DIVISION OF RANDOM HOUSE, INC. · NEW YORK

FIRST VINTAGE INTERNATIONAL EDITION, MARCH 2003

Illustrations from a photograph by Peter Marlow © Peter
Marlow/Magnum Photos

The Library of Congress has cataloged
the Pantheon edition as follows:
Berger, John.
The shape of a pocket / John Berger.
p. cm.
ISBN 0-375-42147-5
1. Art—Themes, motives. I. Title.
N7560.B47 2002 701'.18'09—dc21 2001036513

Vintage ISBN: 0-375-71888-5

www.vintagebooks.com

Printed in the United States of America
10 9 8 7 6 5 4

Contents

1. Opening a Gate 1

2. Steps Towards a Small Theory of the Visible (for Yves) 9

3. Studio Talk (for Miquel Barceló) 25

4. The Chauvet Cave 33

5. Penelope 43

6. The Fayum Portraits 51

7. Degas 61

8. Drawing: Correspondence with Leon Kossoff 69

9. Vincent 85

10. Michelangelo 95

11. Rembrandt and the Body 103

12. A Cloth Over the Mirror 113

13. Brancusi 121

14. The River Po 129

15. Giorgio Morandi (for Gianni Celati) 139

16. Pull the Other Leg, It's Got Bells On It 147

17. Frida Kahlo 155

18. A Bed (for Christoph Hänsli) 165

19. A Man with Tousled Hair 171

20. An Apple Orchard (An Open Letter to Raymond Barre, Mayor of Lyon) 183

21. Brushes Standing Up in Jars 199

22. Against the Great Defeat of the World 207

23. Correspondence with Subcomandante Marcos:

I. The Herons 219

II. The Herons and Eagles 223

III. How to Live with Stones 233

24. Will It Be a Likeness? (for Juan Munoz) 243

1

Opening a Gate

The ceiling of the bedroom is painted a faded sky blue. There are two large rusty hooks screwed into the beams and from these, long ago, the farmer hung his smoked sausages and hams. This is the room in which I'm writing. Outside the window are old plum trees, the fruit now turning raven blue, and beyond them the nearest hill which forms the first step to the mountains.

Early this morning, when I was still in bed, a swallow flew in, circled the room, saw its error and flew out through the window past the plum trees to alight on the telephone wire. I relate this small incident because it seems to me to have something to do with Pentti Sammallahti's photographs. They too, like the swallow, are aberrant.

I have had some of his photographs in the house now for two years. I often take them out of their folder to show to friends who pass. They usually gasp at first, and then peer closer, smiling. They look at the places shown for a longer time than is usual with a photograph. Perhaps they ask whether I know the photographer, Pentti Sammallahti, personally? Or they ask what part of Russia were they taken in? In what year? They never try to put their evident pleasure into words, for it is a secret one. They simply look closer and remember. What?

<p style="text-align:center">* * *</p>

3

In each of these pictures there is at least one dog. That's clear and it might be no more than a gimmick. Yet in fact the dogs offer a key for opening a door. No, a gate – for here everything is outside, outside and beyond.

I notice also in each photograph the special light, the light determined by the time of day or the season of the year. It is, invariably, the light in which figures hunt – for animals, forgotten names, a path leading home, a new day, sleep, the next lorry, spring. A light in which there is no permanence, a light of nothing longer than a glimpse. This too is a key to opening the gate.

The photos were taken with a panoramic camera, such as is normally used for making wide-section geological surveys. Here the wide-section is important, not, I think, for aesthetic reasons but, once again, for scientific, observational ones. A lens with a narrower focus would not have found what I now see, and so it would have remained invisible. What do I now see?

We live our daily lives in a constant exchange with the set of daily appearances surrounding us – often they are very familiar, sometimes they are unexpected and new, but always they confirm us in our lives. They do so even when they are threatening: the sight of a house burning, for example, or a man approaching us with a knife between his teeth, still reminds us (urgently) of our life and its importance. What we habitually see confirms us.

Yet it can happen, suddenly, unexpectedly, and most frequently in the half-light-of-glimpses, that we catch

sight of another visible order which intersects with ours and has nothing to do with it.

The speed of a cinema film is 25 frames per second. God knows how many frames per second flicker past in our daily perception. But it is as if, at the brief moments I'm talking about, suddenly and disconcertingly we see *between* two frames. We come upon a part of the visible which wasn't destined for us. Perhaps it was destined for night-birds, reindeer, ferrets, eels, whales . . .

Our customary visible order is not the only one: it coexists with other orders. Stories of fairies, sprites, ogres were a human attempt to come to terms with this coexistence. Hunters are continually aware of it and so can read signs we do not see. Children feel it intuitively, because they have the habit of hiding behind things. There they discover the interstices between different sets of the visible.

Dogs, with their running legs, sharp noses and developed memory for sounds, are the natural frontier experts of these interstices. Their eyes, whose message often confuses us for it is urgent and mute, are attuned both to the human order and to other visible orders. Perhaps this is why, on so many occasions and for different reasons, we train dogs as guides.

Probably it was a dog who led the great Finnish photographer to the moment and place for the taking of these pictures. In each one the human order, still in sight, is nevertheless no longer central and is slipping away. The interstices are open.

The result is unsettling: there is more solitude, more pain, more dereliction. At the same time, there is an expectancy which I have not experienced since childhood, since I talked to dogs, listened to their secrets and kept them to myself.

2

Steps Towards a Small
Theory of the Visible

(for Yves)

When I say the first line of the Lord's Prayer: 'Our father who art in heaven . . .' I imagine this heaven as invisible, unenterable but intimately close. There is nothing baroque about it, no swirling infinite space or stunning foreshortening. To find it – if one had the grace – it would only be necessary to lift up something as small and as at hand as a pebble or a salt-cellar on the table. Perhaps Cellini knew this.

'Thy kingdom come . . .' The difference is infinite between heaven and earth, yet the distance is minimal. Simone Weil wrote concerning this sentence: 'Here our desire pierces through time to find eternity behind it and this happens when we know how to turn whatever happens, no matter what it is, into an object of desire.'

Her words might also be a prescription for the art of painting.

Today images abound everywhere. Never has so much been depicted and watched. We have glimpses at any moment of what things look like on the other side of the planet, or the other side of the moon. Appearances registered, and transmitted with lightning speed.

Yet with this, something has innocently changed. They used to be called *physical* appearances because they

belonged to solid bodies. Now appearances are volatile. Technological innovation has made it easy to separate the apparent from the existent. And this is precisely what the present system's mythology continually needs to exploit. It turns appearances into refractions, like mirages: refractions not of light but of appetite, in fact a single appetite, the appetite for more.

Consequently – and oddly, considering the physical implications of the notion of *appetite* – the existent, the body, disappears. We live within a spectacle of empty clothes and unworn masks.

Consider any newsreader on any television channel in any country. These speakers are the mechanical epitome of the *disembodied*. It took the system many years to invent them and to teach them to talk as they do.

No bodies and no Necessity – for Necessity is the condition of the existent. It is what makes reality real. And the system's mythology requires only the not-yet-real, the virtual, the next purchase. This produces in the spectator, not, as claimed, a sense of freedom (the so-called freedom of choice) but a profound isolation.

Until recently, history, all the accounts people gave of their lives, all proverbs, fables, parables, confronted the same thing: the everlasting, fearsome, and occasionally beautiful, struggle of living with Necessity, which is the enigma of existence – that which followed from the Creation, and which subsequently has always continued to sharpen the human spirit. Necessity produces both tragedy and comedy. It is what you kiss or bang your head against.

Today, in the system's spectacle, it exists no more. Consequently no experience is communicated. All that is left to share is the spectacle, the game that nobody plays and everybody can watch. As has never happened before, people have to try to place their own existence and their own pains single-handed in the vast arena of time and the universe.

I had a dream in which I was a strange dealer: a dealer in looks or appearances. I collected and distributed them. In the dream I had just discovered a secret! I discovered it on my own, without help or advice.

The secret was to get inside whatever I was looking at – a bucket of water, a cow, a city (like Toledo) seen from above, an oak tree, and, once inside, to arrange its appearances for the better. *Better* did not mean making the thing seem more beautiful or more harmonious; nor did it mean making it more typical, so that the oak tree might represent all oak trees; it simply meant making it more itself so that the cow or the city or the bucket of water became more evidently unique!

The *doing* of this gave me pleasure and I had the impression that the small changes I made from the inside gave pleasure to others.

The secret of how to get inside the object so as to re-arrange how it looked was as simple as opening the door of a wardrobe. Perhaps it was merely a question of being there when the door swung open on its own. Yet when I

woke up, I couldn't remember how it was done and I no longer knew how to get inside things.

The history of painting is often presented as a history of succeeding styles. In our time art dealers and promoters have used this battle of styles to make brand-names for the market. Many collectors – and museums – buy names rather than works.

Maybe it's time to ask a naive question: what does all painting from the Palaeolithic period until our century have in common? Every painted image announces: *I have seen this*, or, when the making of the image was incorporated into a tribal ritual: *We have seen this*. The *this* refers to the sight represented. Non-figurative art is no exception. A late canvas by Rothko represents an illumination or a coloured glow which derived from the painter's experience of the visible. When he was working, he judged his canvas according to something else that he *saw*.

Painting is, first, an affirmation of the visible which surrounds us and which continually appears and disappears. Without the disappearing, there would perhaps be no impulse to paint, for then the visible itself would possess the surety (the permanence) which painting strives to find. More directly than any other art, painting is an affirmation of the existent, of the physical world into which mankind has been thrown.

Animals were the first subject in painting. And right from the beginning and then continuing through Su-

merian, Assyrian, Egyptian and early Greek art, the depiction of these animals was extraordinarily true. Many millennia had to pass before an equivalent 'life-likeness' was achieved in the depiction of the human body. At the beginning, the existent was what confronted man.

The first painters were hunters whose lives, like everybody else's in the tribe, depended upon their close knowledge of animals. Yet the act of painting was not the same as the act of hunting: the relation between the two was magical.

In a number of early cave paintings there are stencil representations of the human hand beside the animals. We do not know what precise ritual this served. We do know that painting was used to confirm a magical 'companionship' between prey and hunter, or, to put it more abstractly, between the existent and human ingenuity. Painting was the means of making this companionship explicit and therefore (hopefully) permanent.

This may still be worth thinking about, long after painting has lost its herds of animals and its ritual function. I believe it tells us something about the nature of the act.

The impulse to paint comes neither from observation nor from the soul (which is probably blind) but from an encounter: the encounter between painter and model – even if the model is a mountain or a shelf of empty medicine bottles. Mont St Victoire as seen from Aix

(seen from elsewhere it has a very different shape) was Cézanne's companion.

When a painting is lifeless it is the result of the painter not having the nerve to get close enough for a collaboration to start. He stays at a *copying* distance. Or, as in mannerist periods like today, he stays at an art-historical distance, playing stylistic tricks which the model knows nothing about.

To go in close means forgetting convention, reputation, reasoning, hierarchies and self. It also means risking incoherence, even madness. For it can happen that one gets too close and then the collaboration breaks down and the painter dissolves into the model. Or the animal devours or tramples the painter into the ground.

Every authentic painting demonstrates a collaboration. Look at Petrus Christus' portrait of a young girl in the Staatliche Museum of Berlin, or the stormy seascape in the Louvre by Courbet, or the mouse with an aubergine painted by Tchou-Ta in the seventeenth century, and it is impossible to deny the participation of the model. Indeed, the paintings are *not* first and foremost about a young woman, a rough sea or a mouse with a vegetable; they are about this participation. 'The brush,' wrote Shitao, the great seventeenth-century Chinese landscape painter, 'is for saving things from chaos.'

It is a strange area into which we are wandering and I'm using words strangely. A rough sea on the northern coast of France, one autumn day in 1870, *participating in being seen* by a man with a beard who, the following year,

will be put in prison! Yet there is no other way of getting close to the actual practice of this silent art, which stops everything moving.

The *raison d'être* of the visible is the eye; the eye evolved and developed where there was enough light for the visible forms of life to become more and more complex and varied. Wild flowers, for example, are the colours they are in order to be seen. That an empty sky appears blue is due to the structure of our eyes and the nature of the solar system. There is a certain ontological basis for the collaboration between model and painter. Silesius, a seventeenth-century doctor of medicine in Wrocklau, wrote about the interdependence of the seen and the seeing in a mystical way:

> *La rose qui contemple ton oeil de chair*
> *A fleuri de la sorte en Dieu dans l'éternel*

How did you become what you visibly are? asks the painter.

I am as I am. I'm waiting, replies the mountain or the mouse or the child.

What for?

For you, if you abandon everything else.

For how long?

For as long as it takes.

There are other things in life.

Find them and be more normal.

And if I don't?

I'll give you what I've given nobody else, but it's worthless, it's simply the answer to your useless question.

Useless?

I am as I am.

No promise more than that?

None. I can wait for ever.

I'd like a normal life.

Live it and don't count on me.

And if I do count on you?

Forget everything and in me you'll find – me!

The collaboration which sometimes follows is seldom based on good will: more usually on desire, rage, fear, pity or longing. The modern illusion concerning painting (which post-modernism has done nothing to correct) is that the artist is a creator. Rather he is a receiver. What seems like creation is the act of giving form to what he has received.

Bogena and Robert and his brother Witek came to spend the evening because it was the Russian new year. Sitting at the table whilst they spoke Russian, I tried to draw Bogena. Not for the first time. I always fail because her face is very mobile and I can't forget her beauty. And to draw well you have to forget that. It was long past midnight when they left. As I was doing my last drawing, Robert said: This is your last chance tonight, just draw her, John, draw her and be a man!

When they had gone, I took the least bad drawing and started working on it with colours – acrylic. Suddenly,

like a weather vane swinging round because the wind has changed, the portrait began to look like something. Her 'likeness' now was in my head – and all I had to do was to draw it out, not look for it. The paper tore. I rubbed on paint sometimes as thick as ointment. At four in the morning the face began to lend itself to, to smile at, its own representation.

The next day the frail piece of paper, heavy with paint, still looked good. In the daylight there were a few nuances of tone to change. Colours applied at night sometimes tend to be too desperate – like shoes pulled off without being untied. Now it was finished.

From time to time during the day I went to look at it and I felt elated. Because I had done a small drawing I was pleased with? Scarcely. The elation came from something else. It came from the face's *appearing* – as if out of the dark. It came from the fact that Bogena's face had made a present of *what it could leave behind of itself.*

What is a likeness? When a person dies, they leave behind, for those who knew them, an emptiness, a space: the space has contours and is different for each person mourned. This space with its contours is the person's *likeness* and is what the artist searches for when making a living portrait. A likeness is something left behind invisibly.

Soutine was among the great painters of the twentieth century. It has taken fifty years for this to become clear, because his art was both traditional and uncouth, and this

mixture offended all fashionable tastes. It was as if his painting had a heavy broken accent and so was considered inarticulate: at best exotic, and at worst barbarian. Now his devotion to the existent becomes more and more exemplary. Few other painters have revealed more graphically than he the collaboration, implicit in the act of painting, between model and painter. The poplars, the carcasses, the children's faces on Soutine's canvases clung to his brush.

Shitao – to quote him again – wrote:

> Painting is the result of the receptivity of ink: the ink is open to the brush: the brush is open to the hand: the hand is open to the heart: all this in the same way as the sky engenders what the earth produces: everything is the result of receptivity.

It is usually said about the late work of Titian or Rembrandt or Turner that their handling of paint became *freer*. Although, in a sense, true, this may give a false impression of *wilfulness*. In fact these painters in their old age simply became more receptive, more open to the appeal of the 'model' and its strange energy. It is as if their own bodies fall away.

When once the principle of collaboration has been understood, it becomes a criterion for judging works of any style, irrespective of their freedom of handling. Or rather (because *judgement* has little to do with art) it offers us an insight for seeing more clearly why painting moves us.

Rubens painted his beloved Hélène Fourment many times. Sometimes she collaborated, sometimes not. When she didn't, she remains a painted ideal; when she did, we too wait for her. There is a painting of roses in a vase by Morandi (1949) in which the flowers wait like cats to be let into his vision. (This is very rare for most flower paintings remain pure spectacle.) There is a portrait of a man painted on wood two millennia ago, whose participation we still feel. There are dwarfs painted by Velázquez, dogs by Titian, houses by Vermeer in which we recognise, as energy, the will-to-be-seen.

More and more people go to museums to look at paintings and do not come away disappointed. What fascinates them? To answer: Art, or the history of art, or art appreciation, misses, I believe, the essential.

In art museums we come upon the visible of other periods and it offers us company. We feel less alone in face of what we ourselves see each day appearing and disappearing. So much continues to look the same: teeth, hands, the sun, women's legs, fish . . . in the realm of the visible all epochs coexist and are fraternal, whether separated by centuries or millennia. And when the painted image is not a copy but the result of a dialogue, the painted thing speaks if we listen.

In matters of seeing Joseph Beuys was the great prophet of the second half of our century, and his life's work was a demonstration of, and an appeal for, the kind of colla-

boration I'm talking about. Believing that everybody is potentially an artist, he took objects and arranged them in such a way that they beg the spectator to collaborate with them, not this time by painting, but by listening to what their eyes tell them and remembering.

I know of few things more sad (sad, not tragic) than an animal who has lost its sight. Unlike humans, the animal has no supporting language left which can describe the world. If on a familiar terrain, the blind animal manages to find its way about with its nose. But it has been deprived of the existent and with this deprivation it begins to diminish until it does little but sleep, therein perhaps hunting for a dream of that which once existed.

The Marquise de Sorcy de Thélusson, painted in 1790 by David, looks at me. Who could have foreseen in her time the solitude in which people today live? A solitude confirmed daily by networks of bodiless and false images concerning the world. Yet their falseness is not an error. If the pursuit of profit is considered as the only means of salvation for mankind, turnover becomes the absolute priority, and, consequently, the existent has to be disregarded or ignored or suppressed.

Today, to try to paint the existent is an act of resistance instigating hope.

3

Studio Talk

(for Miquel Barceló)

A scrap of paper crumpled up and thrown on the studio floor amongst unstretched canvases, on which you stand, pails of pigment – some mixed with clay, the odd saucepan, broken sticks of charcoal, rags, discarded drawings, two empty cups. On the scrap of paper are written two words: FACE and PLACE.

The studio was once a bicycle factory, no? You work here in your painting shoes and clothes. The shirt and trousers were originally striped. Now, like the shoes, they are encrusted with pigment. So I picture you as two people: a man about to ride away on his bicycle and a convict.

However, the only thing which matters, when the day is done, is what lies painted on the floor or leaning against the walls, waiting to be seen the next day. What matters is what the changing light can never quite reveal – the thing, to which one is nearest, when one fears one has probably lost it.

Face. Whatever the painter is looking for, he's looking for its face. All the search and the losing and the re-finding is about that, isn't it? And 'its face' means what? He's looking for its return gaze and he's looking for its expression – a slight sign of its inner life. And this is true

whether he's painting a cherry, a bicycle wheel, a blue rectangle, a carcass, a river, a bush, a hill or his own reflection in a mirror.

Photos, videos, films never find the face; at their best they find memories of appearances and likenesses. The face, by contrast, is always new: something never before seen and yet familiar. (Familiar because, when asleep, we perhaps dream of the face of the whole world, into which at birth we were blindly thrown.)

We see a face only if it looks at us. (Like Vincent's sunflower.) A profile is never a face, and cameras somehow turn most faces into profiles.

When we have to stop before a finished painting, we stop as before an animal who is looking at us. Yes, this is even true for Antonello da Messina's *Pietà with an Angel!* The paint laid or brushed or smeared on to the surface is the animal, and its 'look' is its face. Think of the face of Vermeer's *View of Delft*. Later the animal hides, but it's always there when it first stops us and won't allow us to go on.

An old story that goes back to the caves.

Place, place in the sense of *lieu, luogo, ort, mestopolojenie.* The last Russian word also means *situation* and this is worth remembering.

A place is more than an area. A place surrounds something. A place is the extension of a presence or the consequence of an action. A place is the opposite of empty space. A place is where an event has taken or is taking place.

The painter is continually trying to discover, to stumble upon, the place which will contain and surround his present act of painting. Ideally there should be as many places as there are paintings. The trouble is that a painting often fails to become a place. When it fails to become a place, a painting remains a representation or a decoration – a furnishing.

How does a painting become a place? It's no good the painter looking for the place in nature – it wasn't in Delft that Vermeer found it! Nor can he search for it in art – because, despite the belief of certain post-modernists, references don't make a place. When a place is found it is found somewhere on the frontier between nature and art. It is like a hollow in the sand within which the frontier has been wiped out. The place of the painting begins in this hollow. Begins with a practice, with something being done by the hands, and the hands then seeking the approval of the eye, until the whole body is involved in the hollow. Then there's a chance of it becoming a place. A slim chance.

Two examples. In Manet's *Olympia* the hollow, the place (which of course has nothing to do with the boudoir in which the woman is lying), began in the folds of the bedcover by her left foot.

In a drawing by you of a mango and a knife – they are black and about life-size on a sheet of yellowish paper on to which dust has blown – the place began when you laid the fruit in the curve of the knife's blade. The paper became its own place at that moment.

* * *

The Renaissance notion of perspective, with its predilection for an outside viewpoint, hid, for many people during several centuries, the reality of painting-as-place. Instead, a painting was said to represent the 'view' of a place. Yet this was only theory. In practice the painters themselves knew better. Tintoretto, great late master of perspective, turned the theory on its head, time and again.

In his *Carrying of the Body of St Mark* the painting as place has nothing to do with the perspective of the immense piazza with its arcades and marble paving stones, and everything to do with the haphazard pile of logs in the middle distance on which the saint was going to be cremated. From the brush strokes of those painted branches of wood everything else on the canvas stems – the fleeing figures, the camel's coat of hair, the lightning in the sky, the saint's foreshortened limbs . . . Or, to put it another way, it is from the wood pile that the web of the whole colossal painting was spun.

And since Jacopo Robusti pursues both of us as Tintoretto, here is another example. In his London *Susannah and the Elders* the painting-as-place did not begin with her incomparable body, or with the artful mirror, or with the water coming up to her knee, no, it began in the strange artificial flowering hedge which she is facing and behind which the Elders hide. When Jacopo, with a full brush, began touching the hedge's flowers, he was arranging the place to which everything else had to come. The hedge took over as host and master.

Working alone, the painter knows that far from being able to control the painting from the outside, he has to inhabit it and find shelter in it. He works by touch in the dark.

In your studio the light, towards evening, changes, and the canvases change more than anything else which can be seen. (Far more than the crumpled paper with the two words.) Exactly what changes in them? It is hard to say. Their temperature perhaps and their air pressure. For they do not change in this light like paintings. Each changes like a familiar terrain outside a door. Like places.

How does a painter work in the dark? He has to submit. Often he has to turn around in circles instead of advancing. He prays for collaboration from somewhere else. (In your case from the wind, the termites, the desert sand.) He builds a shelter from which to make forays so as to discover the lie of the land. And all this he does with pigment, brush strokes, rags, a knife, his fingers. The process is highly tactile. Yet what he is hoping to touch is not normally tangible. This is the only real mystery. This is why some – like you – become painters.

When a painting becomes a place, there is a chance that the *face* of what the painter is looking for will show itself there. The longed-for 'return look' can never come directly to him, it can only come through a place.

If the face does come, it is partly pigment, coloured

dirt: partly drawn forms always being corrected: but, most importantly, it is the becoming, the coming-towards-being of what he was searching for. And this becoming is not yet – and, in fact, never will be – tangible, just as the bison on the walls of the canvas were never edible.

What any true painting touches is an absence – an absence of which, without the painting, we might be unaware. And that would be our loss.

The painter's continual search is for a place to welcome the absent. If he finds a place, he arranges it and prays for the face of the absent to appear.

As you know, the face of the absent can be the back-side of a mule! There are no hierarchies, thank God.

Has something been saved? you ask.

This time, yes.

What?

A part, Miquel, of what begins again and again.

4

The Chauvet Cave

You, Marisa, who have painted so many creatures and turned over many stones and crouched for hours looking, perhaps you will follow me.

Today I went to the street market in a suburb south of Paris. You can buy everything there from boots to sea urchins. There's a woman who sells the best paprika I know. There's a fishmonger who shouts out to me whenever he has an unusual fish that he finds beautiful, because he thinks I may buy it in order to draw it. There's a lean man with a beard who sells honey and wine. Recently he has taken to writing poetry, and he hands out photocopies of his poems to his regular clients, looking even more surprised than they do.

One of the poems he handed me this morning went like this:

> *Mais qui piqua ce triangle dans ma tête?*
> *Ce triangle né du clair de lune*
> *me traversa sans me toucher*
> *avec des bruits de libellule*
> *en pleine nuit dans le rocher.*

Who put this triangle in my head?
This triangle born of moonlight

went through me without touching me
making the noise of a dragonfly
deep in the rock at night.

After I read it, I wanted to talk to you about the first painted animals. What I want to say is obvious, something which everybody who has looked at Palaeolithic cave paintings must feel, but which is never (or seldom) said clearly. Maybe the difficulty is one of vocabulary; maybe we have to find new references.

The beginnings of art are being continually pushed back in time. Sculpted rocks just discovered at Kununurra in Australia may date back seventy-five thousands years. The paintings of horses, rhinoceros, ibex, mammoths, lions, bears, bison, panthers, reindeer, aurochs, and an owl, found in 1994 in the Chauvet Cave in the French Ardèche, are probably fifteen thousand years older than those found in the Lascaux caves! The time separating us from these artists is at least twelve times longer than the time separating us from the pre-Socratic philosophers.

What makes their age astounding is the sensitivity of perception they reveal. The thrust of an animal's neck or the set of its mouth or the energy of its haunches were observed and recreated with a nervousness and control comparable to what we find in the works of a Fra Lippo Lippi, a Velázquez, or a Brancusi. Apparently art did not begin clumsily. The eyes and hands of the first painters

and engravers were as fine as any that came later. There was a grace from the start. This is the mystery, isn't it?

The difference between then and now concerns not finesse but space: the space in which their images exist as images and were imagined. It is here – because the difference is so great – that we have to find a new way of talking.

There are fortunately superb photographs of the Chauvet paintings. The cave has been closed up and no public visits will be allowed. This is a correct decision, for like this, the paintings can be preserved. The animals on the rocks are back in the darkness from which they came and in which they resided for so long.

We have no word for this darkness. It is not night and it is not ignorance. From time to time we all cross this darkness, seeing everything: so much everything that we can distinguish nothing. You know it, Marisa, better than I. It's the interior from which everything came.

One July evening this summer, I went up the highest field, high above the farm, to fetch Louis's cows. During the haymaking season I often do this. By the time the last trailer has been unloaded in the barn, it's getting late and Louis has to deliver the evening milk by a certain hour, and anyway we are tired, so, while he prepares the milking machine, I go to bring in the herd. I climbed the track that follows the stream that never dries up. The path was shady and the air was still hot, but not heavy. There were no horseflies as there had

been the previous evening. The path runs like a tunnel under the branches of the trees, and in parts it was muddy. In the mud I left my footprints among the countless footprints of cows.

To the right the ground drops very steeply to the stream. Beech trees and mountain ash prevent it being dangerous; they would stop a beast if it fell there. On the left grow bushes and the odd elder tree. I was walking slowly, so I saw a tuft of reddish cow hair caught on the twigs of one of the bushes.

Before I could see them, I began to call. Like this, they might already be at the corner of the field to join me when I appeared. Everyone has their own way of speaking with cows. Louis talks to them as if they were the children he never had: sweetly or furiously, murmuring or swearing. I don't know how I talk to them; but, by now, they know. They recognise the voice without seeing me.

When I arrived they were waiting. I undid the electric wire and cried: *Venez, mes belles, venez.* Cows are compliant, yet they refuse to be hurried. Cows live slowly – five days to our one. When we beat them, it's invariably out of impatience. Our own. Beaten, they look up with that long-suffering, which is a form (yes, they know it!) of impertinence, because it suggests, not five days, but five aeons.

They ambled out of the field and took the path down. Every evening Delphine leads, and every evening Hirondelle is the last. Most of the others join the file in the

same order, too. The regularity of this somehow suits their patience.

I push against the lame one's rump to get her moving, and I felt her massive warmth, as I did every evening, coming up to my shoulder under my singlet. *Allez*, I told her, *allez, Tulipe*, keeping my hand on her haunch, which jutted out like the corner of a table.

In the mud their steps made almost no noise. Cows are very delicate on their feet: they place them like models turning on high-heeled shoes at the end of their to-and-fro. I've even had the idea of training a cow to walk on a tightrope. Across the stream, for instance!

The running sound of the stream was always part of our evening descent, and when it faded the cows heard the toothless spit of the water pouring into the trough by the stable where they would quench their thirst. A cow can drink about thirty litres in two minutes.

Meanwhile, that evening we were making our slow way down. We were passing the same trees. Each tree nudged the path in its own way. Charlotte stopped where there was a patch of green grass. I tapped her. She went on. It happened every evening. Across the valley I could see the already mown fields.

Hirondelle was letting her head dip with each step, as a duck does. I rested my arm on her neck, and suddenly I saw the evening as from a thousand years away:

Louis's herd walking fastidiously down the path, the stream babbling beside us, the heat subsiding, the trees nudging us, the flies around their eyes, the valley and

the pine trees on the far crest, the smell of piss as Delphine pissed, the buzzard hovering over the field called La Plaine Fin, the water pouring into the trough, me, the mud in the tunnel of trees, the immeasurable age of the mountain, suddenly everything there was indivisible, was one. Later each part would fall to pieces at its own rate. Now they were all compacted together. As compact as an acrobat on a tightrope.

'Listening not to me but to the *logos*, it is wise to agree that all things are one,' said Heraclitus, twenty-nine thousand years after the Chauvet paintings were made.

Only if we remember this unity and the darkness we spoke of, can we find our way into the space of those first paintings.

Nothing is framed in them; more important, nothing meets. Because the animals run and are seen in profile (which is essentially the view of a poorly armed hunter seeking a target) they sometimes give the impression that they're going to meet. But look more carefully: they cross without meeting.

Their space has absolutely nothing in common with that of a stage. When experts pretend that they can see here 'the beginnings of perspective', they are falling into a deep, anachronistic trap. Pictorial systems of perspective are architectural and urban – depending upon the window and the door. Nomadic 'perspective' is about coexistence, not about distance.

Deep in the cave, which meant deep in the earth,

there was everything: wind, water, fire, faraway places, the dead, thunder, pain, paths, animals, light, the unborn . . . They were there in the rock to be called to. The famous imprints of life-size hands (when we look at them we say they are ours) – these hands are there, stencilled in ochre, to touch and mark the everything-present and the ultimate frontier of the space this presence inhabits.

The drawings came, one after another, sometimes to the same spot, with years or perhaps centuries between them, and the fingers of the drawing hand belonging to a different artist.

All the drama that in later art becomes a scene painted *on* a surface with edges is compacted here into the apparition that has come *through* the rock to be seen. The limestone opens for it, lending it a bulge here, a hollow there, a deep scratch, an overhanging lip, a receding flank.

When an apparition came to an artist, it came almost invisibly, trailing a distant, unrecognisably vast sound, and he or she found it and traced where it nudged the surface, the facing surface, on which it would now stay visible even when it had withdrawn and gone back into the one.

Things happened that later millennia found it hard to understand. A head came without a body. Two heads arrived, one behind the other. A single hind leg chose its body, which already had four legs. Six antlers settled in a single skull.

It doesn't matter what size we are when we nudge the surface:

41

we may be gigantic or small – all that matters is how far we have come through the rock.

The drama of these first painted creatures is neither to the side nor to the front, but always behind, in the rock. From where they came. As we did, too . . .

5

Penelope

You have to see them. Words can't get round them. And reproduction sends them back to where they came from. (Most of her works originate in photographs.) You have to be within touching distance of them.

It has been said that Velázquez was (is) very important for her. I can believe it. One or two of the things I want to say about her might also refer to him, but to few other painters I can think of. The precondition for their common stance is a certain form of anonymity, a stepping aside.

Vija Celmins is sixty-three years old. She was born in Riga. Her parents emigrated to the US. For thirty years she lived in Venice, California. Now she is in New York.

My bet is that when she was in the Prado, discovering Velázquez, one painting went straight to her heart – the *Tapestry Weavers*.

She both paints and draws, paints in oils, draws with graphite. The work is highly finished and shows what things look like – an electric fire, for example, a TV set, a hotplate, a pistol. These are not from photos; they are life-size, and painted like the Rokeby Venus. I don't say this to compare genius, but to convey the kind of observation, in which tonal precision is so important, working within a patient and very tactful technique of searching.

Her other subjects are motorways, Second World War planes in the sky, the surface of the moon, Hiroshima after the bomb, the surface of deserts, the mid-ocean, and the night sky with stars. Only it's perhaps misleading to call these her subjects. Rather they are the places from which news came to her in her studio in Venice. And frequently this news came via photographs. (Sometimes, as with the ocean, via photographs she herself took.)

I picture her in her studio shutting her eyes in order to see – because what she wants to see – or has to see – is always far away. She opens them to look only at her drawing. What she does with her shut eyes is like what we do when we put a sea shell to our ear to listen to the sea.

She draws galactic space, she never goes out, and she does not let her considerable imagination run free. To imagine is too easy and too consuming. She knows that she has to stay at her post for years. Doing what? I'd say: waiting.

And this is where Velázquez's *Tapestry Weavers* offers us a clue. Vija Celmins is the artist as Penelope. Far away the pitiless Trojan War continues. Hiroshima is razed. A man on fire runs away. A roof burns. Meanwhile the sea which separates, and the sky which looks down, are utterly indifferent. And here, where she is, nothing is meaningful, except her unlikely and possibly absurd fidelity.

For thirty years she ignored trends, fashion and artistic hyperbole. Her commitment was to the far away. Such fidelity was sustainable because of two things: a deep pictorial scepticism and a highly disciplined patience.

Celmins' scepticism tells her that painting can never get the better of appearances. Painting is always behind. But the difference is that, once finished, the image remains fixed. This is why the image has to be *full* – not of resemblance but of searching. All tricks wear thin. Only what comes unasked has a hope.

She plays a game called *To Fix the Image in Memory*. She takes eleven pebbles from the beach to look at (like everybody does when idle) and she makes casts of them in bronze and paints them. Can you tell which is which? You can? Are you sure? Then how? This is a close-up exercise in scepticism. (And it's a way of giving value to the original pebbles.)

Unlike the first Penelope, she does not undo every night what she has woven during the day – in order to keep her worldly suitors at bay. Yet it comes to the same thing, for next day she will continue to move slowly with her graphite across the shimmering water which never stops and when at last she finishes one sheet of paper, she takes another. Or, if it's the night sky she's doing, she moves from galaxy to galaxy. Her patience comes from an awareness of the distance to be covered.

'I think there's something profound,' she once said, 'about working in material that is stronger than words, and is about some other place which is a little more mysterious.'

None of this would, in itself, be interesting unless you happened to know her and like her. (I myself do not know her.) Her contribution is not to argument. It is

tangible and lies in the mysterious images which are framed behind glass: the images you have to be in touching distance of.

I explain her to myself as Penelope because these images are so handmade (staying at home, head bent, working for years and years), whilst the news they bring – of war, unbearable distances, disappearances, a wisp of smoke from a gun just fired – is bad or threatening.

And this strange marriage leads to a strange transformation. She squares up, square centimetre by square centimetre, the photo of the sea and she transcribes devotedly, forgetting herself. She is too intelligent and too sceptical to copy, she transcribes with all the fidelity she knows. And when at last it is finished, there is an image of the cruel sea, or the cruel sea photographed in a killing instant, and everywhere, all over it, you see the touch of a loving hand. It is visibly and infinitely handmade.

It is the same with all her paintings and drawings. They look unflinchingly at what is, and at what man does, and at the dimensions of solitude, and they are systematically touched with love.

What Homer did with his dactylic hexameters (long-short-short) Celmins does with the pressure of her fingers – a kind of Morse code of the pencil. And so, thanks to this constant measure, her chilling images of distance are warmed, and this gives us pause, makes us wonder.

6

The Fayum Portraits

They are the earliest painted portraits that have survived; they were painted whilst the Gospels of the New Testament were being written. Why then do they strike us today as being so immediate? Why does their individuality feel like our own? Why is their look more contemporary than any look to be found in the rest of the two millennia of traditional European art which followed them? The Fayum portraits touch us, as if they had been painted last month. Why? This is the riddle.

The short answer might be that they were a hybrid, totally bastard art-form, and that this heterogeneity corresponds with something in our present situation. Yet to make this answer comprehensible we have to proceed slowly.

They are painted on wood – often linden, and some are painted on linen. In scale the faces are a little smaller than life. A number are painted in tempera; the medium used for the majority is *encaustic*, that is to say, colours mixed with beeswax, applied hot if the wax is pure, and cold if it has been emulsified.

Today we can still follow the painter's brush strokes or the marks of the blade he used for scraping on the pigment. The preliminary surface on which the portraits

were done was dark. The Fayum painters worked from dark to light.

What no reproduction can show is how appetising the ancient pigment still is. The painters used four colours apart from gold: black, red, and two ochres. The flesh they painted with these pigments makes one think of the bread of life itself. The painters were Greek Egyptian. The Greeks had settled in Egypt since the conquest of Alexander the Great, four centuries earlier.

They are called the Fayum portraits because they were found at the end of the last century in the province of Fayum, a fertile land around a lake, a land called the Garden of Egypt, eighty kilometres west of the Nile, a little south of Memphis and Cairo. At that time a dealer claimed that portraits of the Ptolemies and Cleopatra had been found! Then the paintings were dismissed as fakes. In reality they are genuine portraits of a professional urban middle class – teachers, soldiers, athletes, Serapis priests, merchants, florists. Occasionally we know their names – Aline, Flavian, Isarous, Claudine . . .

They were found in necropolises for they were painted to be attached to the mummy of the person portrayed, when he or she died. Probably they were painted from life (some must have been because of their uncanny vitality); others, following a sudden death, may have been done posthumously.

They served a double pictorial function: they were identity pictures – like passport photos – for the dead

on their journey with Anubis, the god with the jackal's head, to the Kingdom of Osiris; secondly and briefly, they served as mementoes of the departed for the bereaved family. The embalming of the body took seventy days, and sometimes after this, the mummy would be kept in the house, leaning against a wall, a member of the family circle, before being finally placed in the necropolis.

Stylistically, as I've said, the Fayum portraits are hybrid. Egypt by that time had become a Roman province governed by Roman prefects. Consequently the clothes, the hairstyles, the jewellery of the sitters followed the recent fashions in Rome. The Greeks, who made the portraits, used a naturalist technique which derived from the tradition established by Apelles, the great Greek master of the fourth century BC. And, finally, these portraits were sacred objects in a funerary ritual which was uniquely Egyptian. They come to us from a moment of historical transition.

And something of the precariousness of this moment is visible in the way the faces are painted, as distinct from the expression on the faces. In traditional Egyptian painting nobody was seen in full-face because a frontal view opens the possibility to its opposite: the back view of somebody who has turned and is leaving. Every painted Egyptian figure was in eternal profile, and this accorded with the Egyptian preoccupation with the perfect continuity of life after death.

Yet the Fayum portraits, painted in the ancient Greek

tradition, show men, women and children seen full-face or three-quarters full-face. This format varies very little and all of them are as frontal as pictures from a photo-mat. Facing them, we still feel something of the unex-pectedness of that frontality. It is as if they have just tentatively stepped towards us.

Among the several hundred known portraits, the difference of quality is considerable. There were great master-craftsmen and there were provincial hacks. There were those who summarily performed a routine, and there were others (surprisingly many in fact) who offered hospitality to the soul of their client. Yet the pictorial choices open to the painter were minute; the prescribed form very strict. This is paradoxically why, before the greatest of them, one is aware of enormous painterly energy. The stakes were high, the margin narrow. And in art these are conditions which make for energy.

I want now to consider just two actions. First, the act of a Fayum portrait being painted, and, secondly, the action of our looking at one today.

Neither those who ordered the portraits, nor those who painted them, ever imagined their being seen by posterity. They were images destined to be buried, with-out a visible future.

This meant that there was a special relationship between painter and sitter. The sitter had not yet be-come a *model*, and the painter had not yet become a broker for future glory. Instead, the two of them, living

at that moment, collaborated in a preparation for death, a preparation which would ensure survival. To paint was to name, and to be named was a guarantee of this continuity.*

In other words, the Fayum painter was summoned not to make a portrait, as we have come to understand the term, but to register his client, a man or a woman, looking at him. It was the painter rather than the 'model' who submitted to being looked at. Each portrait he made began with this act of submission. We should consider these works not as portraits, but as paintings about the experience of being looked at by Aline, Flavian, Isarous, Claudine . . .

The address, the approach is different from anything we find later in the history of portraits. Later ones were painted for posterity, offering evidence of the once living to future generations. Whilst still being painted, they were imagined in the past tense, and the painter, painting, addressed his sitter in the third person – either singular or plural. *He, She, They as I observed them.* This is why so many of them look old even when they are not.

For the Fayum painter the situation was very different. He submitted to the look of the sitter, for whom he was Death's painter or, perhaps more precisely, Eternity's

* A truly remarkable essay by Jean-Christoph Bailly on the Fayum portraits has just been published (1999) by Hazan, Paris, with the title: *L'Apostrophe Muette.*

painter. And the sitter's look, to which he submitted, addressed him in the second person singular. So that his reply – which was the act of painting – used the same personal pronoun: *Toi, Tu, Esy, Ty . . . who is here.* This in part explains their immediacy.

Looking at these 'portraits' which were not destined for us, we find ourselves caught in the spell of a very special contractual intimacy. The contract may be hard for us to grasp, but the look speaks to us, particularly to us today.

If the Fayum portraits had been unearthed earlier, during, say, the eighteenth century, they would, I believe, have been considered as little more than a curiosity. To a confident, expansive culture these little paintings on linen or wood would probably have seemed diffident, clumsy, cursory, repetitive, uninspired.

The situation at the end of our century is different. The future has been, for the moment, downsized, and the past is being made redundant. Meanwhile the media surround people with an unprecedented number of images, many of which are faces. The faces harangue ceaselessly by provoking envy, new appetites, ambition or, occasionally, pity combined with a sense of impotence. Further, the images of all these faces are processed and selected in order to harangue as noisily as possible, so that one appeal out-pleads and eliminates the next appeal. And people come to depend upon this impersonal noise as a proof of being alive!

Imagine then what happens when somebody comes upon the silence of the Fayum faces and stops short. Images of men and women making no appeal whatsoever, asking for nothing, yet declaring themselves, and anybody who is looking at them, alive! They incarnate, frail as they are, a forgotten self-respect. They confirm, despite everything, that life was and is a gift.

There is a second reason why the Fayum portraits speak today. This century, as has been pointed out many times, is *the* century of emigration, enforced and voluntary. That is to say a century of partings without end, and a century haunted by the memories of those partings.

The sudden anguish of missing what is no longer there is like suddenly coming upon a jar which has fallen and broken into fragments. Alone you collect the pieces, discover how to fit them together and then carefully stick them to one another, one by one. Eventually the jar is reassembled but it is not the same as it was before. It has become both flawed, and more precious. Something comparable happens to the image of a loved place or a loved person when kept in the memory after separation.

The Fayum portraits touch a similar wound in a similar way. The painted faces, too, are flawed, and more precious than the living one was, sitting there in the painter's workshop, where there was a smell of melting beeswax. Flawed because very evidently handmade. More precious because the painted gaze is

entirely concentrated on the life it knows it will one day lose.

And so they gaze on us, the Fayum portraits, like the missing of our own century.

7

Degas

There is love, he once said, and there is a life's work and one only has one heart. So he chose. He put his heart into his life's work. I hope to show to what effect.

His mother, a French American from New Orleans, died when he, her first-born, was only thirteen years old. Apparently, no other woman ever entered into his emotional life. He became a bachelor, looked after by housekeepers. Due to the family banking business he had few material worries. He collected paintings. He was cantankerous. Was called 'a terrible man'. Lived in Montmartre. During the Dreyfus Affair he assumed the conventional anti-Semitism of the average bourgeois. The later photos show a frail old man, kippered by solitude. Edgar Degas.

What makes the story strange is that Degas' art was supremely concerned with women and their bodies. This concern has been misunderstood. Commentators have appropriated the drawings and statues to underwrite their own prejudices, either misogynist or feminist. Now, eighty years after Degas stopped working, it may be time to look again at what the artist left behind. Not as insured masterpieces – the market value of his work has long been established – but as an aid to living.

Pragmatically. Between 1866 and 1890 he made a number of small bronzes of horses. All of them reveal

an intense and lucid observation. Nobody before – not even Géricault – had rendered horses with such a masterly naturalism and fluency. But around 1888 a qualitative change takes place. The style remains exactly the same, but the energy is different. And the difference is flagrant. Any child would spot it immediately. Only some art moralists might miss it. The early bronzes are of horses seen, marvellously seen, out there in the passing, observable world. The later ones are of horses, not only observed but quiveringly perceived from within. Their energy has not just been noted, but submitted to, undergone, borne, as though the sculptor's hands had felt the terrible nervous energy of the horse in the clay he was handling.

The date of this change coincides with Degas' discovery of Muybridge's photographs, which showed for the first time how the legs of horses actually moved when cantering and galloping. And Degas' use of these photographs accords perfectly with the positivist spirit of the epoch. What brought about the *intrinsic* change, however, defies any positivism. Nature, instead of being an object of investigation, becomes a subject. The later works all seem to obey the demands of the model rather than the will of the artist!

Yet perhaps we may be mistaken about the will of this particular artist. For instance, he never expected his statues to be exhibited: they were not made to be finished and presented. His interest in them lay elsewhere.

When Ambrose Vollard, the Impressionists' dealer,

asked Degas why he didn't have his statuettes cast in bronze, he replied that the tin and copper alloy known as bronze was said to be eternal, and he hated nothing more than what was fixed!

Of the seventy-four Degas sculptures that exist in bronze today, all but one were cast after his death. In many cases the original figures, modelled in clay or wax, had deteriorated and crumbled. Seventy others were too far gone to be redeemed.

What can we deduce from this? The statuettes had already served their purpose. (Towards the end of his life Degas stopped exhibiting anything.) The statuettes were not made as sketches or preparatory studies for some other work. They were made for their own sake, yet they had served their purpose: they had reached their point of apogee and so could be abandoned.

The apogee point for him was when the drawn entered the drawing, when the sculpted passed into the sculpture. This was the only rendezvous and transfer that interested him.

I can't explain how the drawn enters a drawing. I only know that it does. One gets closest to understanding this when actually drawing. On Degas' tombstone in the cemetery of Montmartre the only words written are: '*Il aimait beaucoup le dessin.*' ('He liked drawing very much.')

Let us now think of the charcoal drawings, pastels, monotypes and bronzes of women. Sometimes they are presented as ballet dancers, sometimes as women

at their toilette, sometimes (particularly in the mono-
types) as prostitutes. Their presentation is unimportant:
the ballet, the bathtub or the bordel were, for Degas,
only pretexts. This is why any critical discussion about a
pictorial 'scenario' usually misses the point. Why was
Degas so fascinated by women washing themselves? Was
he a keyhole voyeur? Did he consider all women tarts?
(There is an excellent essay by Wendy Lesser in her book
His Other Half in which she dismantles such questions.)

The truth is that Degas simply invented or used any
occasion to pursue his study of the human body. It was
usually women's bodies because he was heterosexual
and so women amazed him more than men, and amaze-
ment is what prompted his kind of drawing.

Straightaway there were people who complained that
the bodies he depicted were deformed, ugly, bestial,
contorted. They even went so far as to assert that he
hated those he drew!

This misunderstanding arose because he disregarded
the conventions of physical beauty as conventionally
transmitted by art or literature. And, for many viewers,
the more a body is naked, the more it should be clothed
in convention, the more it should fit a norm, either a
perverse or an idealised one; the naked have to wear the
uniform of a regiment! Whereas Degas, starting from his
amazement, wanted each profile of the particular body
he was remembering, or watching, to surprise, to be
improbable, for only then would its uniqueness become
palpable.

Degas' most beautiful works are indeed shocking, for they begin and end with the commonplace – with what Wendy Lesser calls 'the dailiness' of life – and always they find there something unpredictable and stark. And in this starkness is a memory of pain or of need.

There is a statuette of a masseuse massaging the leg of a reclining woman which I read, in part, as a confession. A confession, not of his failing eyesight, nor of any suppressed need to paw women, but of his fantasy, as an artist, of alleviating by touching – even if the touch was that of a stick of charcoal on tracing paper. Alleviating what? The fatigue to which all flesh is heir . . .

Many times he stuck additional strips of paper on to his drawings because, master that he was, he lost control of them. The image led him further than he calculated going, led him to the brink, where he momentarily gave way to the other. All his late works of women appear unfinished, abandoned. And, as with the bronze horses, we can see why: at a certain instant the artist disappeared and the model entered. Then he desired no more, and he stopped.

When the model 'entered', the hidden became as present on the paper as the visible. A woman, seen from the back, dries her foot which is posed on the edge of a bath. Meanwhile the invisible front of her body is also there, known, recognised, by the drawing.

A feature of Degas' late works is how the outlines of bodies and limbs are repeatedly and heavily worked. And the reason is simple: on the edge (at the brink), everything on the other, invisible, side is crying out to be

recognised and the line searches . . . until the invisible comes in.

Watching the woman standing on one leg and drying her foot, we are happy for what has been recognised and *admitted*. We feel the existent recalling its own Creation, before there was any fatigue, before the first brothel or the first spa, before the solitude of narcissism, at the moment when the constellations were given names. Yes, this is what we sense watching her keeping her balance.

So what did he leave behind, if it wasn't finished masterpieces?

Do we not all dream of being known, known by our backs, legs, buttocks, shoulders, elbows, hair? Not psychologically recognised, not socially acclaimed, not praised, just nakedly known. Known as a child is by its mother.

One might put it like this. Degas left behind something very strange. His name. His name, which, thanks to the example of his drawings, can now be used as a verb. 'Degas me. Know me like that! Recognise me, dear God! Degas me.'

8

Drawing:
Correspondence with Leon Kossoff

Dear Leon,

I still remember clearly the first time I visited you in your studio, or the room you were then using as a studio. It was some 40 years ago. I remember the debris and the omnipresent hope. The hope was strange because its nature was that of a bone, buried in the earth by a dog.

Now the bone is unburied and the hope has become an impressive, achievement. Except that the last word is wrong, don't you think? To hell with achievement and its recognition, which always comes too late. But a hope of redemption has been realised. You have saved much of what you love.

All this is best not said in words. It's like trying to describe the flavour of garlic or the smell of mussels. What I want to ask you about is the studio.

The first thing painters ask about a studio-space usually concerns the light. And so one might think of a studio as a kind of conservatory or observatory or even lighthouse. And of course light is important. But it seems to me that a studio, when being used, is much more like a stomach. A place of digestion, transformation and excretion. Where images change form. Where everything is both regular and unpredictable. Where there's

no apparent order and from where a well-being comes. A full stomach is, unhappily, one of the oldest dreams in the world. No?

Perhaps I say this to provoke you, because I'd like to know what images a studio (where images are made) suggests to you – you who have spent many years alone in one. Tell me . . .

John

Dear John,

Thank you for your letter. Almost 40 years ago you wrote a very generous piece on my work, *The Weight.* It was the first and, for many years, the only constructive and positive response to the work, and I never thanked you. But I have never forgotten it, and, in the strange time I am living through, now, of having to gather my work (and my life I suppose) together for a first retrospective, I am frequently reminded of it.

All the things you say about the studio are true and the place I work in is much the same as it has always been. A room in a house – a much larger house. There is mess and paint everywhere on the walls – on the floor.

Brushes are drying by the radiator, unfinished paintings are on the walls with drawings of current subjects. There is a place for the model to sit in a corner and a few reproductions on the wall that I've had most of my painting life. I don't worry much about the light, some-

times it can be awkward as the room faces due south, then I turn the painting round or start a new version. I seem engaged in an endless cycle of activities. For the best part of 40 years I have been left alone but recently, owing to extra exposure and studio visits, the place has become like a deserted ship.

Do you remember when we first saw the revealing and moving photographs of Brancusi's and Giacometti's studios in the 1950s? It was a special time. Now every book on every artist includes a photograph of the studio. It has become a familiar stage-set for the artist's work. Has the activity become more important than the resulting image, or does the image need the confirmation of the studio and the myth of the artist because it's not strong enough to be on its own?

I don't know what the work will look like when it finally appears on the walls of the Tate. The main thing that has kept me going all these years is my obsession that I need to teach myself to draw. I have never felt that I can draw and as time has passed this feeling has not changed. So my work has been an experiment in self-education.

Now, after all this drawing, if I stand before a vast Veronese I experience the painting as an exciting exploratory drawing in paint. Or, looking at Velázquez's *Pope Innocent X,* at present in the National Gallery, I wonder, after moving to the nearby early *Christ after Flagellation,* at the transformation of his

capacity to draw with paint. Recently I saw a book of Fayum portraits [the Egyptian mummy paintings] and, thinking about their closeness to Cézanne and the best Picasso, I am reminded of the importance of drawing to all art since the beginning of time. I know this is all familiar to you – even simplistic – but it's where I begin and end.

The exhibition will commence with the thick painting you wrote about. Will the later, relatively lighter and thinner work be seen to have emerged out of my need to relate to the outside world by teaching myself to draw?

Yours, Leon

Dear Leon,

I don't, of course, find your thought about drawing 'simplistic'. I too have been looking at that extraordinary book of Fayum portraits. And what first strikes me, as it must strike everybody, is their thereness. They are there in front of us, here and now. And that's why they were painted – to remain here, after their departure.

This quality depends on the drawing and the complicity, the inter-penetrations, between the head and the space immediately around it. (Perhaps this is partly why we think of Cézanne.) But isn't it also to do with something else – which perhaps approaches the secret of this so mysterious process which we call drawing – isn't it also to do with the collaboration of the sitter? Sometimes the

sitter was alive, sometimes dead, but one always senses a participation, a will to be seen, or, maybe, a waiting-to-be-seen.

It seems to me that even in the work of a great master, the difference between his astounding works and the rest, always comes down to this question of a collaboration with the painted, or its absence.

The romantic notion of the artist as creator eclipsed – and today the notion of the artist as a star still eclipses – the role of receptivity, of openness in the artist. This is the pre-condition for any such collaboration.

So-called 'good' draughtsmanship always supplies an answer. It may be a brilliant answer (Picasso sometimes), or it may be a dull one (any number of academics). Real drawing is a constant question, is a clumsiness, which is a form of hospitality towards what is being drawn. And, such hospitality once offered, the collaboration may sometimes begin.

When you say: 'I need to teach myself to draw,' I think I can recognise the obstinacy and the doubt from which that comes. But the only reply I can give is: I hope you never learn to draw! (There would be no more collaboration. There would only be an answer.)

Your brother Chaim (in the larger 1993 portrait) is there like one of the ancient Egyptians. His spirit is different, he has lived a different life, he is awaiting something different. (No! that's wrong, he's awaiting the same thing but in a different way.) But he is equally

there. When somebody or something is there, the painting method seems to be a detail. It is like the self-effacement of a good host.

Pilar (1994) is there to a degree that makes us forget every detail. Through her body, her life was waiting to be seen, and it collaborated with you, and your drawing in paint allowed that life to enter.

You don't draw in paint in the same way as Velázquez – not only because times have changed, but also because time has changed, your openness is not the same either (he with his open scepticism, you with your fervent need for closeness), but the riddle of collaboration is still similar.

Maybe when I say *your* 'openness', I'm simplifying and being too personal. Yes, it comes from you, but it passes into other things. In your painting of Pilar, the surface of pigment, those gestures one upon another like the household gestures of a mother during a life-time, the space of the room – all these are *open* to Pilar and her body waiting-to-be-seen. Or is it, rather, waiting-to-be-recognised?

In your landscapes the receptivity of the air to what it surrounds is even more evident. The sky opens to what is under it and in *Christchurch Spitalfields, Morning 1990,* it bends down to surround it. In *Christchurch Stormy Day, Summer 1994,* the church is equally open to the sky. The fact that you go on painting the same motif allows these collaborations to become closer and closer. Perhaps in painting this is what intimacy

means? And you push it very far, in your own unmistakable way. For the sky to 'receive' a steeple or a column is not simple, but it's something clear. (It's what, during centuries, steeples and columns were made for.) And you succeed in making an early summer suburban landscape 'receive', be open to, a diesel engine!

And there I don't know how you do it! I can only see that you've done it. The afternoon heat has something to do with it? But how does that heat become drawing? How does such heat draw in paint? It does, but I don't know how. What I'm saying sounds complex. In fact all I'm saying is already there in your marvellous and very simple title: *Here Comes the Diesel.*

You say that on the walls of your painting rooms there are some reproductions which have been pinned there for years. I wonder what? Last night I dreamt I saw at least one. But this morning I've forgotten it.

I suppose that soon you'll be hanging the paintings at the Tate. I've never done it but I guess it's a very hard moment. It's difficult to hang paintings well because their *therenesses* compete. But apart from this difficulty, what I guess is hard is being forced to see them as exhibits. For Beuys it was OK because his collaboration was with the spectator. But for iconic works like yours it may seem, I imagine, like a dislocation, and therefore a violence. Yet don't worry – they will hold their own. They

are coming from their own place, like the train between Kilburn and Willesden Green.

With affection and respect
John

Dear John,
No one has written about the work of drawing and painting with such directness and selfless insight as you have in your last letter to me. That it's 'my' work you are writing about is less important than the fact that, through your words, you acknowledge the separateness and independence of the images.

'Thereness' follows nothingness. It is impossible to premeditate. It is to do with the collaboration of the sitter, as you say, but also to do with the disappearance of the sitter the moment the image emerges. Is this what you mean by 'the self-effacement of the good host'? The Fayum portraits of course emerge out of an attitude to life and death quite different from our own. In the pyramids there was life after death and the life was in the 'thereness' of the portraits. If there is something of this quality in the painting of Pilar it has more to do with the processes I am involved with than trying to paint a certain picture.

Pilar came to sit for me some years ago. She comes two mornings a week. For the first two or three years I drew from her. Then I started to paint her. Painting consists of working over the whole board quickly, trying to relate what was happening on the board to what I

thought I was seeing. The paint is mixed before starting – there is always more than one board around to start another version. The process goes on a long time, sometimes a year or two. Though other things are happening in my life which affect me, the image that I might leave appears moments after scraping, as a response to a slight change of movement or light. Similarly with the landscape paintings. The subject is visited many times and lots of drawings are made, mostly very quickly. The work is begun in the studio where each new drawing means a new start until, one day, a drawing appears which opens up the subject in a new way, so I work from the drawing as I do from the sitter. It's the process I am engaged in that is important.

I'm not too worried about the hanging of the paintings. The Tate are very good at this. The experience will be very strange. I haven't seen many of the pictures for a very long time and as the event draws closer I become more aware that the work will represent an experiment in living which has been exciting, interesting and extending so I'm not so concerned about success or failure as I am about holding myself together to keep the experiment going. This is rather difficult.

The reproductions I have had on my wall since my student days are the Rembrandt *Bathsheba*, a late Michelangelo drawing, the Philadelphia Cézanne, *Achille Empaire* by Cézanne, and a photograph of some

early works by Frank Auerbach. About 20 years ago I added a head by Velázquez (*Aesop*) and a portrait by Delacroix. I don't look at them much but they are there.

Yours Leon

The portrait by Delacroix is of Apasie. I almost forgot the *Judgement of Solomon* by Poussin.

Dear Leon,

Yes, the disappearance of the sitter at a certain moment. And you're right, I left that out. The image takes over. And in your case the image comes through all the vicissitudes of paint, board, plastering on, drawing, and scraping off: vicissitudes which produce something so movingly close to the wear and tear of life. So the image unpremeditatedly, as you say, takes over. And the slow process of discovering what is there without disturbing it, begins. Sometimes of destroying what's there without disturbing it. (Eavesdroppers may consider us mad, but it's true.) Then after all that, or during all that, isn't there something else happening? The sitter – who may be a train, a church, a swimming pool – comes back through the canvas! It's as if she disappears, vanishes, merges with everything else – takes a long journey on a kind of Inner Circle (which may last months or a year) and then re-emerges in the stuff with which all this time you've been struggling. Or am I again being too simple?

The 'sitter' is at first here and now. Then she dis-

appears and (sometimes) comes back there, inseparable from every mark on the painting.

After she has 'disappeared' a drawing or two are the only clues about where she may have gone. And of course sometimes they're not enough, and she never comes back . . .

Yes, at our age the most important thing is to 'hold things together' to 'keep the experiment going'. And it's (most of the time) rather difficult.

I guess the Bathsheba is the one where she's holding a letter? And on her forearm she's wearing a bracelet which, in a way I can't understand but probably you can, is the keystone of the whole painting? And that marvellous rear leg in shadow, and everything tentative except her body.

My friend the Spanish painter, Barceló, has made a whole book of reliefs with a text in Braille to be felt with the fingers by those who are blind. And this makes me see that if a blind person felt Bathsheba's body and then felt Pilar's or Cathy's, they would have the sensation of touching similar flesh. And this similarity is not to do with a similar way of painting but with a comparable respect for flesh, paint and their vicissitudes, their endless vicissitudes. The *Aesop* of Velázquez I too have lived with for years. A strange coincidence, Leon, no?

And again, at a level which has nothing to do with method, I see something in common between *Aesop* and your brother *Chaim* (1993). Something said by

their presence. 'He observes, watches, recognises, listens to what surrounds him and is exterior to him, and at the same time he ponders within, ceaselessly arranging what he has perceived, trying to find a sense which goes beyond the five senses with which he was born. The sense found in what he sees, however precarious and ambiguous it may be, is his only real possession.'

Last week I was looking at *Aesop* in Madrid, in the same room as the head of a deer, in the same life as Willesden and a children's swimming pool.

Tell me how you are.

I salute you! (Incorrigible Latin that I am in my exuberance, blackness notwithstanding.)

John.

PS: What sort of music do you like?

Dear John,

Thank you for your letter. I am still thinking about 'thereness' and the Velázquez portrait of *Aesop*. Referring to a book on the artist I noticed that the author writes 'the picture is by no means a portrait but rather an amalgam of literary and visual sources successfully disguised under a veneer of realism'. Art historians can get away with anything! So I went back to Pacheco, the painter and father-in-law of Velázquez – who wrote – 'I keep to nature for everything and in the case of my son-in-law who follows this course one can see how he differs from all the rest because he

always works from life', and later 'those who have excelled as draughtsmen will excel in this field' (portraits).

Reading Pacheco, one realises that Velázquez must have been drawing continuously and it becomes possible to begin to understand how the image of Aesop might have emerged in a few moments at the end of a long day's painting, as the artist turned away from the work he was engaged upon, to encounter this extraordinary person who had entered the studio. Velázquez was the ultimate example of the artist working at speed turning drawing into painting like Degas and Manet after him. Drawing from life in paint becomes 'thereness'.

And there's something else – the effort of your friend Barceló on behalf of the blind reminds me that recently I heard a blind man talking on the radio about his experience of light. He said: 'Reassuring, encouraging people makes a kind of light.' (I know this is not what you are saying but doesn't 'touch' produce a kind of light also?) This blind man knew somehow that light would occur through the deepening of his relationship with the outside world. And so it is with painting. It is impossible to set out to paint light. Light in a painting makes its own appearance. It occurs as a result of a resolution of the relationships within the work. The painter might be driven by anxiety but the light in the final work (I'm thinking of Cézanne) is as much a surprise to him as it is a

delight to us. In a sense, before the work is resolved, the painter is, in a certain way, blind.

It is possible we become more 'Latin' as we grow older. In my case I wish it was the other way round. Perhaps not. These days I feel I should have been born nearer the Mediterranean in the first place.

Yours, Leon

9

Vincent

Is it still possible to write more words about him? I think of those already written, mine included, and the answer is 'No'. If I look at his paintings, the answer is again – for a different reason – 'No'; the canvases command silence. I almost said *plead for*, and that would have been false, for there is nothing pathetic about a single image he made – not even the old man with his head in his hands at the gates of eternity. All his life he hated blackmail and pathos.

Only when I look at his drawings does it seem worthwhile to add to the words. Maybe because his drawings resemble a kind of writing, and he often drew on his own letters. The ideal project would be to *draw* the process of his drawing, to borrow his drawing hand. Nevertheless I will try with words.

In front of a drawing, drawn in July 1888, of a landscape around the ruined abbey of Montmajour near Arles, I think I see the answer to the obvious question: Why did this man become the most popular painter in the world?

The myth, the films, the prices, the so-called martyrdom, the bright colours, have all played their part and amplified the global appeal of his work, but they are not at its origin. He is loved, I said to myself in front of the

drawing of olive trees, because for him the act of draw-
ing or painting was a way of discovering and demonstrat-
ing why *he* loved so intensely what he was looking at, and
what he looked at during the eight years of his life as a
painter (yes, only eight) belonged to everyday life.

I can think of no other European painter whose work
expresses such a stripped respect for everyday things
without elevating them, in some way, without referring
to salvation by way of an ideal which the things embody
or serve. Chardin, de la Tour, Courbet, Monet, de Staël,
Miro, Jasper Johns – to name but a few – were all
magisterially sustained by pictorial ideologies, whereas
he, as soon as he abandoned his first vocation as a
preacher, abandoned all ideology. He became strictly
existential, ideologically naked. The chair is a chair, not
a throne. The boots have been worn by walking. The
sunflowers are plants, not constellations. The postman
delivers letters. The irises will die. And from this naked-
ness of his, which his contemporaries saw as naivety or
madness, came his capacity to love, suddenly and at any
moment, what he saw in front of him. Picking up pen or
brush, he then strove to realise, to *achieve* that love.
Lover-painter affirming the toughness of an everyday
tenderness we all dream of in our better moments and
instantly recognise when it is framed . . .

Words, words. How is it visible in his practice? Return
to the drawing. It's in ink, drawn with a reed-pen. He
made many such drawings in a single day. Sometimes,
like this one, direct from nature, sometimes from one of

his own paintings, which he had hung on the wall of his room whilst the paint was drying.

Drawings like these were not so much preparatory studies as graphic hopes; they showed in a simpler way – without the complication of handling pigment – where the act of painting could hopefully lead him. They were maps of his love.

What do we see? Thyme, other shrubs, limestone rocks, olive trees on a hillside, in the distance a plain, in the sky birds. He dips the pen into brown ink, watches, and marks the paper. The gestures come from his hand, his wrist, arm, shoulder, perhaps even the muscles in his neck, yet the strokes he makes on the paper are following currents of energy which are not physically his and *which only become visible when he draws them.* Currents of energy? The energy of a tree's growth, of a plant's search for light, of a branch's need for accommodation with its neighbouring branches, of the roots of thistles and shrubs, of the weight of rocks lodged on a slope, of the sunlight, of the attraction of the shade for whatever is alive and suffers from the heat, of the Mistral from the north which has fashioned the rock strata. My list is arbitrary; what is not arbitrary is the pattern his strokes make on the paper. The pattern is like a fingerprint. Whose?

It is a drawing which values precision – every stroke is explicit and unambiguous – yet it has totally forgotten itself in its openness to what it has met. And the meeting is so close you can't tell whose trace is whose. A map of love indeed.

Two years later, three months before his death, he painted a small canvas of two peasants digging the earth. He did it from memory because it refers back to the peasants he painted five years earlier in Holland and to the many homages he paid throughout his life to Millet. It is also, however, a painting whose theme is the kind of fusion we find in the drawing.

The two men digging are painted in the same colours – potato brown, spade grey and the faded blue of French work clothes – as the field, the sky and the distant hills. The brush strokes describing their limbs are identical to those which follow the dips and mounds of the field. The two men's raised elbows become two more crests, two more hillocks, against the horizon.

The painting is not of course declaring these men to be 'clods of earth', the term used by many citizens at that epoch to insult peasants. The fusion of the figures with the ground refers fiercely to the reciprocal exchange of energy that constitutes agriculture, and which explains, in the long term, why agricultural production cannot be submitted to purely economic law. It may also refer – by way of his own love and respect for peasants – to his own practice as a painter.

During his whole short life he had to live and gamble with the risk of self-loss. The wager is visible in all the self-portraits. He looks at himself as a stranger, or as something he has stumbled upon. His portraits of others are more personal, their focus more close-up. When things went too far, and he lost himself utterly, the conse-

quences, as the legend reminds us, were catastrophic. And this is evident too in the paintings and drawings he made at such moments. Fusion became fission. Everything crossed everything else out.

When he won his wager – which was most of the time – the lack of contours around his identity allowed him to be extraordinarily open, allowed him to become permeated by what he was looking at. Or is that wrong? Maybe the lack of contours allowed him to lend himself, to leave and enter and permeate the other. Perhaps both processes occurred – once again as in love.

Words. Words. Return to the drawing by the olive trees. The ruined abbey is, I think, behind us. It is a sinister place – or would be if it were not in ruins. The sun, the Mistral, lizards, cicadas, the occasional hoopoe bird, are still cleaning its walls (it was dismantled during the French Revolution), still obliterating the trivia of its one-time power and insisting upon the immediate.

As he sits with his back to the monastery looking at the trees, the olive grove seems to close the gap and to press itself against him. He recognises the sensation – he has often experienced it, indoors, outdoors, in the Borinage, in Paris or here in Provence. To this pressing – which was perhaps the only sustained intimate love he knew in his lifetime – he responds with incredible speed and the utmost attention. Everything his eye sees, he fingers. And the light falls on the touches on the vellum paper just as it falls on the pebbles at his feet – on one of which (on the paper) he will write Vincent.

Within the drawing today there seems to be what I have to call a gratitude, which is hard to name. Is it the place's, his or ours?

10

Michelangelo

I am craning my neck to look up at the Sistine Chapel ceiling and the *Creation of Adam* – do you think, like me, that once you dreamt the touch of that hand and the extraordinary moment of withdrawal? And pfff! I picture you in your faraway Galician kitchen restoring a painted Madonna for a small village church. Yes, the restoration here in Rome has been well done. The protests were wrong, and I can tell you why.

The four kinds of space Michelangelo played with on the ceiling – the space of bas-relief, the space of high-relief, the corporeal space of the twenty nudes whom he dreamt as a beatitude as he lay painting on his back, and the infinite space of the heavens – these distinct spaces are now clearer and more astonishingly articulated than they were before. Articulated, Marisa, with the aplomb of a master snooker player! And if the ceiling had been badly cleaned, this would have been the first thing lost.

I've discovered something else too: it leaps to the eye but no one quite faces up to it. Perhaps because the Vatican is so formally imposing. Between its worldly wealth on one hand, and its list of eternal punishments on the other, the visitor is made to feel exceedingly small. The excessive riches of the Church and the excessive punishments the Church prescribed were

really complementary. Without Hell, the wealth would have appeared as Theft! Anyway, visitors today from all over the world are so awed they forget about their little things.

But not Michelangelo. He painted them, and he painted them with such love they became focal points, so that for centuries after his death, the Papal authorities had one male sex after another in the Sistine Chapel covertly scratched out or painted over. Happily there are still quite a few that remain.

During his lifetime he was referred to as 'the sublime genius'. Even more than Titian he assumed – at the very last possible historical moment – the Renaissance role of the artist as supreme creator. His exclusive subject was the human body, and for him that body's sublimity lay revealed in the male sexual organ.

In Donatello's *David* the young man's sex is discreetly in its proper place – like a thumb or a toe. In Michelangelo's *David* the sex is the body's centre and every other part of the body refers back to it with a kind of deference, as if to a miracle. As simple and as beautiful as that. Less spectacularly, but none the less evidently, the same is true of his *Bruges Madonna* and the sex of the infant Christ. It was not lust but a form of worship.

Given this predilection and all the pride of the Renaissance genius, what would you say his imaginary paradise might have been? Might it not have been the fantasy of men giving birth?

The whole ceiling is really about Creation and for

him, in the last coil of his longing, Creation meant everything imaginable being born, thrusting and flying, from between men's legs!

Remember the Medici tomb with the figures of Night and Day, Dusk and Dawn? Two reclining men and two reclining women. The women modestly fold their legs together. Both men part their legs and, pushing, lift their pelvises, as though waiting for a birth. Not a birth of flesh and blood and not – heaven forbid – of symbols either. The birth they await is of the indescribable and endless mystery which their bodies incarnate, and which will emerge from there, from between their parted legs.

And so it is on the ceiling. The visitors in the Chapel floor are like figures who have just dropped from between the feet and out of the skirts of the Prophets and Sibyls. OK. The Sibyls are women, but not really, not when you get close: they are men in drag.

Beyond, are the nine scenes of the Creation and there, at the four corners of each scene, sit the amazing, twisting, immense, labouring male nudes (the *ignudi*), whose presence commentators have found so difficult to explain. They represent, some claim, Ideal Beauty. Then why their effort, why their longing and their labour? No, the twenty young naked men up there have conceived and just given birth to all that is visible and all that is imaginable and all that we see on the ceiling. Man's loved body up there is the *measure* of everything – even of platonic love, even of Eve, even of you.

He once said, talking about the sculptor of the

Bevedere Torso (50 BC): 'This is the work of a man who knew more than nature!'

And therein lay the dream, the coiled desire, the pathos and the illusion.

In 1536, two decades after he finished the ceiling, he started to paint the *Last Judgement* on the gigantic wall behind the altar. Maybe it's the biggest fresco in Europe? Countless figures, all naked, mostly men. Other writers have compared it with the late works of Rembrandt or Beethoven but I can't follow them. What I see is pure terror and the terror is intimately connected with the ceiling above. Man on this wall is still naked but now the measure of nothing!

Everything has changed. The Renaissance and its spirit is finished. Rome has been sacked. The Inquisition is about to be set up. Everywhere fear has replaced hope, and he is growing old. Maybe it's like our world today.

Suddenly the pictures of Sebastiao Salgado come to my mind: his photos of the Brazilian gold mine and of coal miners in Bihar, India. Both artists are appalled by what they have to depict, and both show bodies strained to a similar breaking point, which, somehow, the bodies endure!

There the resemblance ends, for Salgado's figures are working and his are monstrously unemployed. Their energy, their bodies, their huge hands, their senses, have become useless. Mankind has become barren, and there is scarcely any difference between the saved and the

damned. No dream remains in any body, however beautiful that body once was. There is only anger and penance – as if God has abandoned man to nature and nature has become blind! Blind? Finally, it's not true.

He lived and worked for another two decades after he painted the *Last Judgement.* And when he died, at the age of eighty-nine, he was carving a marble Pietà. The so-called unfinished *Rondanini Pietà.*

The mother who holds up the limp body of her son is in roughly carved stone. The son's two legs and one of his arms are finished and polished. (Maybe they are the remnants of another sculpture he partially destroyed – it doesn't matter: this monument to his energy and solitude stands as it is.) The crossing line, the frontier between the smooth marble and the rough stone, between the flesh and the block of rock, is at the level of Christ's sex.

And the immense pathos of this work comes from the fact that the body is returning, is being breathed back with love into the block of stone, into his mother. It is, at last, the opposite of any birth!

I'll send you Salgado's photo of Galician women wading into the Ria de Vigo, searching in the month of October for shellfish at low tide . . .

11

Rembrandt and the Body

At the age of sixty-three he died, looking, even by the standards of his time, very old. Drink, debts, the death through the Plague of those nearest to him are amongst the explanations of the ravages done. But the self-portraits hint at something more. He grew old in a climate of economic fanaticism and indifference – not dissimilar to the climate of the period we are living through. The human could no longer simply be copied (as in the Renaissance), the human was no longer self-evident: it had to be found in the darkness. Rembrandt himself was obstinate, dogmatic, cunning, capable of a kind of brutality. Do not let us turn him into a saint. Yet he was looking for a way out of the darkness.

He drew because he liked drawing. It was a daily reminder of what surrounded him. Painting – particularly in the second half of his life – was for him something very different: it was a search for an exit from the darkness. Perhaps the drawings – with their extraordinary lucidity – have prevented us seeing the way he really painted.

He seldom made preliminary drawings, he began painting straightaway on the canvas. There is little of either linear logic or spatial continuity in his paintings. If

the pictures convince, they do so because details, parts, emerge and come out to meet the eye. Nothing is laid out before us as it is in the work of his contemporaries like Ruysdael or Vermeer.

Whereas in his drawings he was a total master of space, of proportion, the physical world he presents in his paintings is seriously dislocated. In art studies about him this has not been emphasised enough. Perhaps because one needs to be a painter rather than a scholar to perceive it clearly.

There is an early painting of a man (it's himself) before an easel in a studio. The man is not much more than half the size he should be! In the marvellous late painting *Woman at an Open Door* (Berlin) Hendrickje's right arm and hand are the size of those of a Hercules! In *Abraham's Sacrifice* (St Petersburg) Isaac has the physique of a youth but in proportion to his father is no larger than an eight-year-old!

Baroque art loved foreshortenings and improbable juxtapositions, but, even if he profited by the liberties won by the Baroque, the dislocations in his paintings are in no way similar, for they are not *demonstrative*: they are almost furtive.

In the sublime *St Matthew and Angel* (The Louvre) the impossible space over the Evangelist's shoulder for the Angel's head is furtively insinuated, as if by the whisper the Angel is whispering into the writer's ear. Why in his paintings did he forget – or ignore – what he could do with such mastery in his drawings? Something else –

something antithetical to 'real' space – must have inter-
ested him more.

Leave the museum. Go to the emergency department of
a hospital. Probably in a basement because the X-ray
units are best placed underground. There are the
wounded and the sick being wheeled forward, or waiting
for hours, side by side, on their trolleys, until the next
expert can give them attention. Often it is the rich,
rather than the most sick, who pass first. Either way, for
the patients, there underground, it is too late to change
anything.

Each one is living in her or his own corporeal space, in
which the landmarks are a pain or a disability, an
unfamiliar sensation or a numbness. The surgeons when
operating cannot obey the laws of this space – it is not
something learnt in Dr Tulip's Anatomy Lesson. Every
good nurse, however, becomes familiar by touch with it –
and on each mattress, with each patient, it takes a
different form.

It is the space of each sentient body's awareness of itself.
It is not boundless like subjective space: it is always finally
bound by the laws of the body, but its landmarks, its
emphasis, its inner proportions are continually changing.
Pain sharpens our awareness of such space. It is the space
of our first vulnerability and solitude. Also of disease. But
it is also, potentially, the space of pleasure, well-being and
the sensation of being loved. Robert Kramer, the film-
maker, defines it: 'Behind the eyes and throughout the

body. The universe of circuits and synapses. The worn paths where the energy habitually flows.' It can be felt by touch more clearly than it can be seen by sight. He was the painterly master of this corporeal space.

Consider the four hands of the couple in *The Jewish Bride*. It is their hands, far more than their faces, which say: Marriage. Yet how did he get there – to this corporeal space?

Bathsheba Reading David's Letter (The Louvre). She sits there life-size and naked. She is pondering her fate. The King has seen her and desires her. Her husband is away at the wars. (How many millions of times has it happened?) Her servant, kneeling, is drying her feet. She has no choice but to go to the King. She will become pregnant. King David will arrange for her fond husband to be killed. She will mourn for her husband. She will marry King David and bear him the son who will become King Solomon. A fatality has already begun, and at the centre of this fatality is Bathsheba's desirability as a wife.

And so he made her nubile stomach and navel the focus of the entire painting. He placed them at the level of the servant's eyes. And painted them with love and pity as if they were a face. There isn't another belly in European art painted with a fraction of this devotion. It has become the centre of its own story.

On canvas after canvas he gave to a part of a body or to parts of bodies a special power of narration. The paint-

ing then speaks with several voices – like a story being told by different people from different points of view. Yet these 'points of view' can only exist in a coporeal space which is incompatible with territorial or architectural space. Corporeal space is continually changing its measures and focal centres, according to circumstances. It measures by waves, not metres. Hence its necessary dislocations of 'real' space.

The Holy Family (Munich). The Virgin is seated in Joseph's workshop. Jesus is asleep on her lap. The relation between the Virgin's hand holding the baby, her bare breast, the baby's head and his outstretched arm is absurd in terms of any conventional pictorial space: nothing fits, stays in its proper place, is the correct size. Yet the breast with its drop of milk speaks to the baby's face. The baby's hand speaks to the amorphous landmass which is his mother. Her hand listens to the infant it is holding.

His best paintings deliver coherently very little to the spectator's point of view. Instead, the spectator intercepts (overhears) dialogues between parts gone adrift, and these dialogues are so faithful to a corporeal experience that they speak to something everybody carries within them. Before his art, the spectator's body remembers its own inner experience.

Commentators have often remarked on the 'innerness' of Rembrandt's images. Yet they are the opposite of ikons. They are carnal images. The flesh of the *Flayed Ox*

is not an exception but typical. If they reveal an 'inner-ness' it is that of the body, what lovers try to reach by caressing and by intercourse. In this context the last word takes on both a more literal and more poetic meaning. Coursing between.

About half of his great masterpieces (portraits apart) depict the act or the preliminary act – the opening of the outstretched arms – of an embrace. *The Prodigal Son, Jacob and the Angel, Danaë, David and Absalom, The Jewish Bride* . . .

Nothing comparable is to be found in the *oeuvre* of any other painter. In Rubens, for instance, there are many figures being handled, carried, pulled, but few, if any, embracing. In nobody else's work does the embrace occupy this supreme and central position. Sometimes the embrace he paints is sexual, sometimes not. In the fusion between two bodies not only desire can pass, but also pardon or faith. In his *Jacob and the Angel* (Berlin) we see all three and they become inseparable.

Public hospitals, dating from the Middle Ages, were called in France Hôtels-Dieu. Places where shelter and care were given in the name of God to the sick or dying. Beware of idealisation. The Hôtel-Dieu in Paris was so overcrowded during the Plague that each bed was 'occupied by three people, one sick, one dying and one dead'.

Yet the term Hôtel-Dieu, interpreted differently, can help to explain him. The key to his vision, which had to

dislocate classical space, was The New Testament. 'Who lives in love lives in God and God in him . . . We know that we live in him and he in us because he has given us of his Spirit.' (The First Epistle of John. Ch.4)

'He in us'. What the surgeons found in dissecting was one thing. What he was looking for was another. Hôtel-Dieu may also mean a body in which God resides. In the ineffable, terrible late self-portraits, he was waiting, as he gazed into his own face, for God, knowing full well that God is invisible.

When he painted freely those he loved or imagined or felt close to, he tried to enter their corporeal space as it existed at that precise moment, he tried to enter their Hôtel-Dieu. And so to find an exit from the darkness.

Before the small painting of *A Woman Bathing* (London) we are with her, inside the shift she is holding up. Not as voyeurs. Not lecherously like the Elders spying on Susannah. It is simply that we are led, by the tenderness of his love, to inhabit her body's space.

For Rembrandt, the embrace was perhaps synonymous with the act of painting, and both were just this side of prayer.

12

A Cloth Over the Mirror

The late Rembrandt self-portraits contain or embody a paradox: they are clearly about old age, yet they address the future. They assume something coming towards them apart from Death.

Twenty years ago in front of one of them in the Frick Collection, New York, I wrote the following lines:

> The eyes from the face
> two nights look at the day
> the universe of his mind
> doubled by pity
> nothing else can suffice.
> Before a mirror
> silent as a horseless road
> he envisaged us
> deaf dumb
> returning overland
> to look at him
> in the dark.

At the same time there is a cheek, an insolence, in the painting which makes me think of a verbal self-portrait in a story I like very much by the American polemicist and fiction writer, Andrea Dworkin:

I have no patience with the untorn, anyone who hasn't weathered rough weather, fallen apart, been ripped to pieces, put herself back together, big stitches, jagged cuts, nothing nice. Then something shines out. But these ones all shined up on the outside, the ass wigglers, I'll be honest, I don't like them. Not at all.

Big stitches, jagged cuts. That's how the paint is put on.

Yet, finally, if we want to get closer to what makes the late self-portraits so exceptional, we have to relate them to the rest of the genre. How and why do they differ from most other painted self-portraits?

The first known self-portrait dates from the second millennium BC. An Egyptian bas-relief which shows the artist in profile drinking from a jar that his patron's servant is offering him at a feast where there are many other people. Such self-portraits – for the tradition continued until the early Middle Ages – were like artists' signatures to the crowded scenes being depicted. They were a marginal claim that said: *I also was present.*

Later, when the subject of St Luke painting the Virgin Mary became popular, the painter often painted himself in a more central position. Yet he was there because of his act of painting the Virgin: he was not yet there to look into himself.

One of the first self-portraits to do precisely this is Antonello da Messina's which is permanently in the

National Gallery, London. This painter (1430–1479) who was the first southern painter to use oil paint had an extraordinary Sicilian clarity and compassion – such as one finds later in artists like Varga, Pirandello or Lampedusa. In the self-portrait, he looks at himself as if looking at his own judge. There is not a trace of dissimilation.

In most of the self-portraits that were to follow, play acting or dissimilation was endemic. And there is a phenomenological reason for this. A painter can draw his left hand as if it belonged to somebody else. Using two mirrors he can draw his own profile as if observing a stranger. But when he looks straight into a mirror, he is caught in a trap: his reaction to the face he is seeing changes that face. Or, to put it in another way, that face can offer itself something it likes or loves. The face arranges itself. Caravaggio's painting of Narcissus is a perfect demonstration.

It is the same for all of us. We play-act when we look in the bathroom mirror, we instantly make an adjustment to our expression and our face. Quite apart from the reversal of the left and right, nobody else ever sees us as we see ourselves above the washbasin. And this dissimilation is spontaneous and uncalculated. It's as old as the invention of the mirror.

Throughout the history of self-portraits a similar 'look' occurs again and again. If the face is not hidden in a group, one can recognise a self-portrait a mile off, because of its particular kind of theatricality. We watch

Dürer playing Christ, Gauguin playing the outcast, Delacroix the dandy, the young Rembrandt the successful Amsterdam trader. We can be moved as if by overhearing a confession, or amused as by a boast. Yet before most self-portraits, because of the exclusive complicity existing between the eye observing and the returned gaze, we have a sense of something opaque, a sense of watching the drama of a double-bind which excludes us.

True, there are exceptions: self-portraits which do look at *us*: a Chardin, a Tintoretto, a copy of a Frans Hals self-portrait when he was bankrupt, Turner as a young man, the old Goya as an exile in Bordeaux. Nevertheless, they are few and far between. And so how is it that during the last ten years of his life Rembrandt painted nearly twenty portraits which address us directly?

When you're trying to do a portrait of somebody else, you look very hard at them, searching to find what is there, trying to trace what has happened to the face. The result (sometimes) may be a kind of likeness, but usually it is a dead one, because the presence of the sitter and the tight focus of observation have inhibited your response. The sitter leaves. And it can then happen that you begin again, referring not any more to a face in front of you, but to the recollected face which is now inside you. You no longer peer; you shut your eyes. *You begin to make a portrait of what the sitter has been left behind in your head.* And now there is a chance that it will be alive.

Is it possible that Rembrandt did something similar

with himself? I believe he used a mirror only at the beginning of each canvas. Then he put a cloth over it, and worked and reworked the canvas until the painting began to correspond to an image of himself which had been left behind after a lifetime. This image was not generalised, it was very specific. Each time he made a portrait he chose what to wear. Each time he was highly aware of how his face, his stance, his appearance had changed. He studied the damage unflinchingly. Yet, at a certain moment, he covered the mirror so that he no longer had to adjust his gaze to his gaze, and then he continued to paint only from what had been left behind inside him. Freed from the double-bind, he was sustained by a vague hope, an intuition, that later it would be others who would look at him with a compassion that he could not allow himself.

13

Brancusi

Thank you for the painting, Marisa, I've put glass over it. Your painted man, and around him the horizons, and beside him the real, not painted, lichen which has resisted drought and every extreme of temperature for millions of years. Primeval lichen, petals, feathers – you keep them between pages and you take one out, like a ticket from a purse, whenever you paint a journey!

Me? I'm standing in the biggest ever Brancusi exhibition. No lichen, no feathers, nothing itches here. Almost everything is polished and pure.

I have the impression, that just after Brancusi's death in 1957 I visited his studio in the Impasse Ronsin. I was with a friend – perhaps with Zadkine who was also a friend of his. I remember the name BRANCUSI scrawled on the door with a horseshoe hung beside it, the high skylights, the vice on his bench and the sculptures and the famous carved pedestals and the segments of his Column-without-end, all crowded together but never jostling one another – each work platonically arm in arm with its neighbour.

Particularly I remember the benevolent presence of the man who had just been buried in the cemetery of Montparnasse. The studio seemed to me to be like a

bakery, the ovens still warm, from which the baker had just walked out to go down to the river.

Yet is this true? Was I really there or have I made it up, my imagination influenced by all the flaring, mysterious photos he took of his studio, or by a visit I made to the reconstructed one which was later opened as a museum?

There's nobody I can check with today. Yet the doubt is appropriate, for Brancusi had the perplexing gift of being entirely himself and, at the same time, always slipping away. (He was seven years old when he ran away from his home in the Carpathian Mountains the first time.) It's not birds that I sculpt, he once said, it's the act of flying.

He dressed like a Russian peasant yet his friend Marcel Duchamp sold Brancusi's sculptures in the 1920s to avant-garde collectors in the USA, where they were viewed as shining emblems of the modern era.

His first sculpted birds were inspired by the mythical bird of the Romanian forests called the Maïastra. When he came to Paris from Bucharest in 1904 he made most of the journey on foot. Yet his last birds, made in the 1930s, already prophesy the form of the Concorde jet!

When you look at his drawings, they have the air of maps, which is odd for a sculptor. The contours don't mould forms, they simply mark frontiers which can be crossed. All his work is about leaving. Above all about leaving the earth for the sky, as his Columns-without-end are supposed to do.

And standing here, Marisa, I suddenly want to resist. I

think of one of your feathers falling down on to the earth. Maybe I love the imperfect and the flawed too much. I want to find out how to judge the rascal. He'll remain great, of course, but we ought to know a bit more about his pain.

There's a work in the show called *Sculpture for the Blind*. It's an oval, lying on its side, made of marble, about the size of an ostrich's egg but not so symmetrical.

Say somebody blind picks it up and starts feeling it, fascinated, with their fingertips. Is this slight ridge the place of a nose? Is this gentle hollow becoming an eye-socket? Can the ripple here be a hair-line? After a while they'll turn the egg over and start touching it to discover whether there is a crack, as with an Easter egg that opens. And finally they'll ask themselves a question: Is this thing I'm holding in my hands a container or a core? Is there a head within it, or is it a head coming into being?

Now, this work is one of a long series of horizontal oval heads made between 1910 and 1928. Some he called *The Sleeping Muse*, others *The New Born, The Beginning of the World, First Cry, Prometheus*. Obviously Brancusi imagined them as cores not containers.

And he strove for the same thing in all his polished carvings – the birds, the fishes, the princesses. Each time when carving, he wanted to go back, eliminating all imperfections, all wear and tear, to the growing point of the first Creation, to the pure idea as it takes on form. Platonic once more. That he spent months polishing his sculptures was an integral part of that return journey to

the pure, to that which existed before gravity and before the Fall.

The preposterous challenge the rascal set himself was to do this using heavy, earthy materials such as marble, bronze and oak. Sometimes he succeeded, sometimes he failed. When he fails the polished form does remain a case, a container, and doesn't become the core. When he succeeds, the material is utterly transformed by the movement he miraculously gives it. In the case of the big, flat *Fish*, the marble becomes water.

Nearly all the birds and fishes succeed, as also the oval heads. The penguins, the tortoises, the torsos, Leda, the smart women, fail. They remain containers. At the best like sea shells and at the worst, like custom-built motorbike petrol tanks.

The notorious story of how in 1927 the US customs taxed one of Brancusi's sculptures because they considered it, not a work of art, but an industrial utensil, is often retold as an example of bureaucratic philistinism. It seems to me that their colossal error was a little understandable, and not quite as stupid as is made out.

I think the old man in his solitude sensed the problem of the containers. And if during his last twenty years he made almost nothing new, it was probably because he realised that he had found all he was likely to find. After all, there are not that many cores, and the infinite multiplicity of feathers, leaves, barks, skins is *NOT* what interested him.

With one exception. The exception which is his most

astonishing invention. *The Kiss.* He made the first one in 1907 and he went on making others till 1940. This is the most recurring theme in his *oeuvre*, a counterpart to the bird. All the *Kisses* are in rough stone. Not one is polished and not one is platonic.

All the versions show an embracing couple carved out of a single block of stone which remains very rectangular, like a pillar. Their two eyes in profile form a single eye, their four lips a single mouth. A shallow line marks the frontier of their two skins pressed together. The outermost surface of the block stands in for their four encircling arms, which end in their poor open hands, pressing the other inwards, breast to breast.

The stone now does not have to transcend its material nature. It remains earthbound, part of the same world as lichen and moss and feathers. And although these couples are recognisably by the same artist, they aspire to something very different from the rest of his work.

In face of them one encounters what came, not before the Fall, but afterwards. The stocky lovers are on this side, on our side, in all our usual mess. They are not seeking perfection; they are simply longing to be a bit more complete. Time and again with the *Kisses* the old rascal instilled an ache into stone: the ache of a desire for a lost unity.

Thank you again, Marisa, for your man and the lichen stuck on the coarse paper . . .

14

The River Po

Michelangelo Antonioni comes from Ferrara – in the simple sense that he was born there, but also, in a more complex way, because the city or its spirit is invariably present in his work. (It seems to me that even his face and the way he is handsome is an expression of that city of Ariosto and the house of Este.)

Today a strange city of small luxuries (small in dimension, jewel-like, reminiscent of the objects in the paintings of Cosimo Tura) and great sadness. A city where young women marry and become mothers and then the mothers are inexplicably transformed into stepmothers. A city where fathers unaccountably become strangers to their children. Where nothing, however familiar, is what it appears to be, and everything becomes slowly more and more distant.

I have no right to say this, for I have never lived there, but every visit during forty years has confirmed this impression, and when I began reading the stories of Bassani, I came to the conclusion it was probably true. A city like a glass case whose panes are always misting up. Containing what? A secret. Maybe a necklace of secrets. Or maybe a weapon, if so, a cruel one.

Whoever says Ferrara, says also the River Po. Other places are more intimate with the river – Cremona,

Torino, the little town of Paesana near its source, but Ferrara is its monument, its mortuary headstone. After Ferrara the river begins to negotiate and finally join the *beyond*. This dimension of the beyond is marvellously held at the end of Antonioni's first nine-minute documentary film, *Gente del Po*, made between 1943 and 1947.

The plain of the Po has given northern Italy its wealth, but the river is unpredictable, always shifting, meandering, refusing norms. A sprawling story of regular repetitions and unpredictability. It silts up. It pushes the sea back! Its riverbed gets higher and higher – hence the everlasting danger of floods. On the surface she is still (the Po is a feminine river – perhaps the most feminine in the world: by contrast the Danube is male) but deeper down, there are invisible, ferocious currents. Beware all inexperienced boatmen! The Po irrigates, offers harvests and is indifferent, as are all rivers.

In Antonioni's film the river is the chief character, defined by her colossal will, but not her impatience, to reach the sea. When she does, the sea, instead of embracing her, gives her a leg up and she clambers into the white bed of the sky.

The other principal characters in *Gente del Po* are the captain of the tugboat, hauling five barges down the river, the captain's wife and their daughter, who is down below in her bunk for she has been taken ill. The mother goes ashore to buy a remedy for her daughter in the chemist's shop of a poor riverside village. The tugboat is called *Milano* and the river constantly reminds

the villagers of *elsewhere*. This was twenty years before Italy's postwar economic miracle.

In Antonioni's later films the milieu tends to be rich and elegant rather than rural proletarian. Yet isn't it true that in most of them there is a search for a remedy? A remedy which never quite works – despite all the effort.

This first, brief, black-and-white film without spoken dialogue is prophetic in another way too. In it we today recognise Antonioni's special way of framing his shots – as though the focus of his interest is always *beside* the event shown, and the protagonist is never centred, because the centre is a destiny we do not understand and whose outline is not yet clear.

Essentially his cinematic handwriting hasn't changed since he began making this first film when he was thirty-one years old. An immense evolution is to come – including that of colour – but the same vision, the same pair of eyes was already there in 1943.

Whoever says Po, says Fog. It is part of the river's character, like the smell of her skin. The Po was the first river – years after this film was made – on which radar was installed, for her worst fogs are impenetrable.

The fogs extend over the plain of the Po, creating a very special atmosphere and tension, which writers like Gianni Celati and, earlier, Césare Pavese have described so well.

To understand this tension one has to ask the question of what is hidden by the fog and what isn't. In the

sunlight the plain is flat and wide and long, often stretching to the horizon; the roads are straight; the farmhouses are rectangular; the poplars are in perfect line; the irrigation channels never meander. It's impossible to imagine a less mysterious landscape. (In Holland, for example, there is always the tumult of the sky.) This lack of mystery is not, however, reassuring, for the scale of the plain and its geometry and inevitability dwarf anything that is only 2 m. high – like a man or a woman. The desert dwarfs with the authority of God; the plain of the Po dwarfs with the banality of a remorseless, regulated calendar. And so, somewhere, the soul prays for fog and it's the only prayer to which the river listens.

The fog comes. The air gets polluted. The isolation becomes insupportable. The lorries have their headlights on, even if they pull over and stop. The claustrophobia mounts. But in the mystery of what's behind the fog there is – nothing as simple and naive as a hope for the people of Emilia have watched everything – there is a memory, similar to the memory of a mother. (I do not think in psychoanalytic terms, and have never done so, but in climatic ones.)

I might call this memory the Madonna of the Fog. This is the most red, least mystic, least Catholic part of Italy. (Perhaps during the war she was a Partisan.) In any case everyone knows her when the visibility has been reduced to a few metres. Barely discernible, she stands there, arms extended, palms towards us, announcing that the truth is invisible (with all the ambiguity of that

phrase) and that we should close our eyes in order to bring everything together!

The film that Antonioni is now making with Wim Wenders begins and finishes with a fog in Ferrara. And its provisional title is *Beyond the Clouds*. After the four stories, which constitute the film, have been told, the narrator says:

> We know that behind every image revealed there is another image more faithful to reality, and in the back of that image there is another, and yet another behind the last one and so on up to the true image of that absolute, mysterious reality that no one will ever see.

Those who admire Antonioni's films often say that he narrates like a novelist. Those who criticise his films often accuse them of being abstract, over-aesthetic, formalist. It seems to me that if one wants to enter the world of his imagination, one should first think of him as a painter. Human behaviour and stories interest him, but he begins with what somebody or somewhere *looks* like. His most important perceptions are pre-verbal. (This is perhaps why he can use silence so well.) Kieslowski, for example, is a real novelist of the cinema because he thinks about the consequence of actions. Antonioni gazes at the *silhouette* of an action, with all the painter's desire to find in it something that is timeless. I would even go so far as to suggest he often forgets the consequence.

Since Antonioni exhibits as a painter, I'm not

pointing out anything very original here. But if we go back to the Po and the Madonna of the Fog, and if we remember how he's a painter, we discover, I think, a clue to his life's work.

Antonioni's films question the visible until there's not enough light to see any more. The visible may be Monica Vitti or Marcello Mastroianni or a river bank or a ship's hull or a tree or a tennis court. Unlike a true painter he can't touch the image with his hands; he has to worry it in other ways – by lighting, by movement, by waiting, by a kind of cinematic stealth. His purpose is to make us peer into his films as one peers into the Po as it flows, as Monet peered into the depths of his water lily pond, as one walks peering through the fog.

The hope which, I believe, sustained him as he made each film, was that, as we peer, something will come to meet us, something that almost escaped him, something so real that it doesn't have a name.

Halfway through *Gente del Po* a peasant on the river bank sharpens a scythe and a line of women, dressed in black, rake hay. One of the women straightens her back to gaze at the river as the barges pass. She is young. She is like nobody else. She has slightly protruding white teeth when she smiles. And she smiles, because whilst she gazes at the wide river with its colossal will to reach the sea, something comes out of it to meet her. We can read it on her face. But on the film we can't see it.

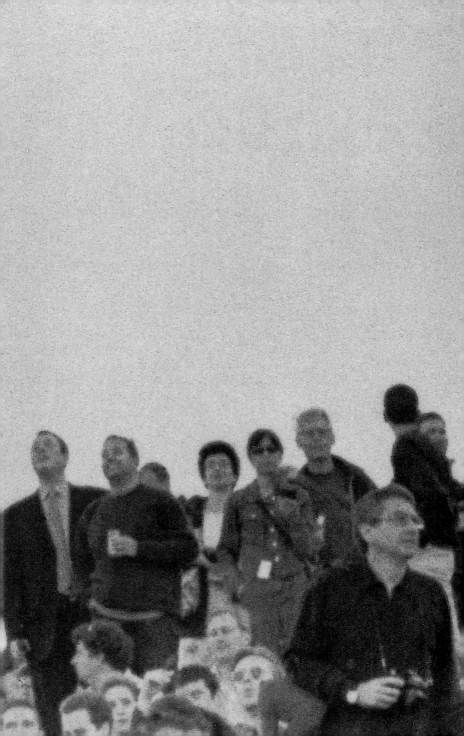

15

Giorgio Morandi

(for Gianni Celati)

He was a solitary who lived all his life surrounded by people. The opposite of a hermit. A man closely linked to the everyday life of his neighbours and town, who nevertheless pursued and developed the purity of his own solitude. This is a very specially Italian phenomenon. It is what can happen behind the shutters and the sunblinds. The solitude not of the forest or the cave but of sunlight reflected from a perfectly built wall.

He remained unmarried in a way which is also particularly Italian. Nothing much to do with celibacy or sexual predilection. Rather a hazard determined by statistics – as if each city (in this case Bologna) needs a required number of bachelors and spinsters. What is particularly Italian is the way the hazard is accepted and finally enjoyed as if it were a wrapped sweetmeat served with strong bitter coffee.

His face became like that of a sexton, but a sexton for whom the modest role of looking after the precious objects in the sacristy was not a second-best but rather, the chosen vocation. The face of a virile not timid sexton.

In the late 1920s he believed wholeheartedly in fascism. Later he believed in the discipline of art. This is probably why he did not resent the economic necessity

of teaching. He taught engraving and the discipline had to be spotless. Today it is hard to imagine an art less political and more intrinsically opposed to fascism (because totally opposed to any form of demagogy) than Morandi's.

My guess is that, with his solitude, with his pursuit of reticence, with his daily routines and the lifelong repetition of the motifs he chose to paint (he only had three subjects), he became during the last years of his life a fairly difficult man – in the sense of being obstinate, crotchety and wary.

It may be, however, that just as each city requires a certain number of unmarried citizens, each moment of art needs somewhere a furiously obstinate recluse, inaudibly muttering against over-simplification. In art the temptation to please too easily is ever present: it comes with mastery. The obstinacy of the recluses, familiar with failure, is art's saving grace. Before Morandi, in the nineteenth century there were Cézanne and Van Gogh; after him – Nicholas de Staël or Rothko. These very different painters shared only one thing: an undeviating (and to themselves unforgiving) sense of aim.

Morandi's three subjects were flowers, the few bottles and knick-knacks he kept on a shelf, and what he happened to see outside. The term 'landscape' suggests something too grand. The trees and walls and patches of grass he chose to paint are no more than what you glance at when you pause on a road to mop your brow in the afternoon heat.

142

In 1925, when he was thirty-five, he painted a self-portrait. His face is not yet that of the sexton, but the solitude is already there. He sits alone on a stool, listening perhaps to the murmurs from the piazza which come through the open window (we do not see the window) and he says nothing. Nothing because no words can express the intensity of what he guesses as he listens. This kind of silence in a country where so many people sing is also very Italian. (Throughout his life he left Italy only once for a short visit to Switzerland.)

In his left hand he holds a brush. (That he was left-handed is, I feel, important but I do not know why.) In his right hand he holds a palette on which the pigments are exactly the same colours as those that surround him as background. This artful reminder that what we are seeing, including the image of the painter himself, first began with mixing colours tells us something about what is to come.

His art divides itself into three periods, the difference between them being subtle. From the time of the self-portrait until 1940, he paints in order to approach the object being painted – the path under the tree, the flowers in the vase, the tall bottles. We follow him closer and closer. The eventual closeness has nothing to do with detail or photographic precision. It is a question of the presence of the object, almost its body temperature being felt.

In the second period, between 1940 and 1950, I have

the impression that the painter stays still and that the objects (the same ones with an occasional sea shell added) are approaching the canvas. He waits and they arrive. Perhaps he is in hiding, so as to encourage them.

In the final period, from 1951 until his death in 1964, the objects seem to be on the point of disappearing. Not that they are faint or far away. Rather they are weightless, in flux, on the frontier of existence.

If we assume this is a progression – that a mastery increased as he grew older – we have to ask: What was he trying to do? The answer, often given – that Morandi is the poet of the ephemeral – doesn't convince me. The energy of his work is neither nostalgic nor – in any personal sense – intimate. In his life he may have shut himself away. And his odious politics suggest panic. Yet his art is strangely affirmative. Of what?

The drawings and etchings whisper an answer. Because there is no density and no colour the objects there don't distract us. And we realise that what interests the artist is the process of the visible first becoming visible, before the thing seen has been given a name or acquired a value. The lonely life's work of the crotchety sexton is about beginnings!

One has to imagine the world as a sheet of paper and a creator's hand drawing, trying out objects which don't yet exist. Traces are not only what is left when something has gone, they can also be marks for a project, of something to come. The visible begins with light. And as soon as there is light there is shade. The hand draws

shadows on the white of the paper. All drawing is a shadow around light.

The marks weave together, quiver, alternate. And slowly the eye registers and reads the unrepeatable pattern of a particular branch of leaves trembling in front of a particular sunlit wall.

In other words, the objects he paints can be bought in no flea market. They are not objects. They are places (everything has its place), places where some little thing is coming into being.

When the old recluse lay in his bed in the morning, the light of the day was there before he opened his eyes, allocating shadows and brightness in the room and in the street outside. Every morning the tide of the visible carried him a little way towards the present before he opened his eyes to look at anything!

Later in his studio he tried, through the act of painting, to refind and indicate this tide. Morandi, in his solitude, was in love, not with appearances, but with the *project* of appearances. And he was, incidentally, the stealthiest painter ever.

16

Pull the Other Leg, It's Got Bells On It

The church of St Eustace, according to the guide books, is the most beautiful church in Paris after La Notre-Dame. It was built in the sixteenth century beside Les Halles, the fruit and vegetable market of the city since the Middle Ages. Visiting the church today you find in one of its chapels something between a sculpture, a fresco and a high-relief. Three metres long, three metres high, and vividly coloured. It has as title: *Departure of Fruit and Vegetables from the Heart of Paris.* It is signed Raymond Mason and is dated 1969, which was the year when Les Halles was closed and the legendary Paris market removed to a city suburb.

The *Departure* is awkward in many senses of the word, and one doesn't know how to place it. Is it a theatrical tableau for kids? A kind of Nativity crèche? Is it Fine Art? What is it doing in a church?

There is something coarse about it. The figures have been modelled with a hand that was all thumbs. (Or so one might think at first.) The colours are primitive: the lettuces are lettuce green, the tomatoes slapstick red, the carrots carroty. The scene depicted is at night, a little before dawn, the time when the market opened, and so in the lamplight the figures have pallid faces and crumpled clothes. Banal. Everyday. Every night. Yet if

you stay watching this work, its company grows on you and becomes immense, until it fills the entire church.

Why do original works of art often strike us, at first, as being coarse, awkward and difficult to place?

Raymond Mason has sculptures on permanent display in the Paris Tuileries Gardens (apart from St Eustace), in New York, in Montreal, in Vezelay. In 1991 the Queen of England unveiled *Forward, a Monument for Birmingham*. Yet his work has never been fashionable and now never will be.

In the 1930s there was a boy who, because he was asthmatic, often didn't go to school. His father was a taxi driver in Birmingham which at that time was still the most important industrial city in Britain. Breathing in his asthma-powder, Raymond sits by the window of the red-brick terraced house, and watches people pass and repass and talk in the street outside. This was the very beginning.

The sixteenth-century peasants of Flemish villages still live in Brueghel's paintings. Raymond Mason's art embodies lives from the skilled industrial proletariat of the twentieth century: the lives of the men and women he observed when a boy. It took him thirty years or more to acquire in Paris, where he has lived since 1946, the mastery necessary to do them justice in sculpture. And now they too live – however unfashionably for the moment – in three masterpieces: *Departure of Fruit and Vegetables, A Tragedy in the North* – inspired by a mining disaster in Liévin – and *The Grape Pickers*, now installed at Vezelay.

To be faithful as a sculptor to the proletariat is not as simple as it may sound, and not as simple as certain idiots and bigots once insisted. First, observation and love are necessary. Oddly, love is the best guarantee against idealisation. Then observation and observation, drawing upon drawing. One has to become familiar with every physical characteristic – the way bodies develop, the different way clothes are worn, the whole vocabulary of gestures. (Some of this can now be seen in the seventy-three-year-old artist's own face.)

In 1963 Mason made a plaster bas-relief, life-size, of a man's back and shoulders. (The same back appears much later in *The Grape Pickers*.) Unidealised, it is physically heroic; not a slave's back for it shows pride, nor an athlete's for it is too worn. Perhaps it is Sisyphus' back, stripped to the waist for its endurance. Or, yesterday, the back of Heavy Industry.

Ten years earlier, in 1953, Mason had made a bronze relief of a tram with its morning passengers in Barcelona. I still remember the impression this work made on me when I first saw it. Here were workers – men and women – and here was everyday street sensuality being observed, modelled and cast in bronze by an unknown artist who obviously thought of himself as a direct descendant of Donatello and Ghiberti! The insolence of it! Yet behind the admirable insolence there was also a contradiction, a problem.

The industrial proletariat lived without the Aesthetic Principle. Never for a moment did they believe in, or act

upon, the idea that virtue – or any other quality – might be deduced from appearances. They didn't believe that the good looked good. For the most part they weren't ascetic or puritan; they treated appetite and exuberance as a natural part of life, but not Beauty.

Beauty they saw as a trick, a ruse, a cosmetic lie. A term that expresses something of this defiance is the compliment of calling somebody 'a rough diamond'; i.e., a gem that looks like a piece of slag! The Beauty they discovered for themselves was an invisible one closely connected with endurance and companionship.

In any proper representation of the proletariat therefore this suspicion of Beauty ought to be taken account of; otherwise they risk, once represented, to be no more than pawns in somebody else's aesthetic or political game. This was a question Mason wrestled with until he was nearly fifty. How not to fall into the trap of Beauty?

In 1969 he decided to stop casting his life-size plaster sculptures in bronze and to cast them, instead, in epoxy resin. This would allow him to paint them in acrylic. And this is what he did. He began painting his monuments in the derisory colours of proletarian life: the colours of wool shops, knitting needles, tartan caps, bicycle saddles, Woolworth toys, jam tarts, tobacco tins, pale faces waiting for the stigmata of lipstick kisses, mittens, permed hair.

When I look at these works I see them speaking of things and of a kind of love that I know nobody will ever find in Matisse or Botticelli or Frank Stella.

Of course in sculpture it's not colour which carries the

work; colours refer to vernacular, lifestyle, certain memories; the work has to stand or fall according to what it does with space. Space for sculptures is what voices are for theatre. It is the space a work creates within and around itself which articulates its strength, its joy or its suffering.

As one might have expected from the son of a Birmingham taxi driver, Raymond Mason finally found a way of creating a sculptural space which plays extraordinarily both with the topographical and with narrative. Stories you hear as you drive your fare through the back streets.

The space of his big sculptural groups consists of flows which run between the figures or the little islands of figures, like currents in a river. Mason talks about 'the torrent of life'. You peer through the ravine between two bodies, you look over the boulder of a shoulder, or between a pair of legs, or under a raised arm, or around a couple, and each time your gaze is swept away to another form, another life. And these lives add up – as the scenes from a silent Chaplin film add up, except that here, in epoxy resin, everything is present for ever and nothing moves.

His mastery of this created synthetic space allows the onlooker to become *simultaneously* aware of a crowd who have gathered, of receding streets and red bricks which never end, and of the knotted veins meandering across the back of a working man's hand. Among other artists probably only Verdi had such an embracing love of the popular.

Mason's masterpieces are awkward monuments made

during the last quarter of this century to a class that was slowly disappearing, with many of its members forced into terminal unemployment. A class which today scarcely exists but which left the world its own word: solidarity.

I don't think Mason thought about this as a project; it was in his blood, or, to put it more finely, it was in what he took for granted and worked from.

Return to the church of St Eustace and look again. Look at the guy with a cauliflower and his mate with a Swiss chard under his arm, and the bloke with a big nose holding up a case of oranges as if it were a chalice, and the black kid with a cabbage, and the woman with a pom-pom hat and cherry lips who is carrying a case of Starking apples which press against her bosom, and the man pulling a wagon, and the tomato which has fallen on to the street and squashed. I look and say to myself: I've seen saints in churches and Madonnas and martyrs and the saved and the damned, but I've never seen people straight off the street except when they're sitting on the pews, and here they have a chapel to themselves and have been made sacred! (They themselves wouldn't believe it. Pull the other leg, it's got bells on it, they'd say.) Made sacred not by the company of the surrounding saints, nor by the buried generals in their sarcophagi, but by the tenderness of an artist who remembered them with love, and re-created them indefatigably.

17

Frida Kahlo

They were known as the Elephant and the Butterfly –
although her father called her the Dove. When she died,
more than forty years ago, she left behind a hundred
and fifty small paintings, a third of which are classified as
self-portraits. He was Diego Rivera and she was Frida
Kahlo.

Frida Kahlo! Like all legendary names, it sounds like
an invented one, but wasn't. During her lifetime she was
a legend, both in Mexico and – amongst a small circle of
artists – in Paris. Today she is a world legend. Her story
has been told and retold very well – by herself, by Diego,
and later by many others. Victim of polio as a child,
horribly crippled again in a bus accident, introduced to
painting and communism by Diego, their passion, mar-
riage, divorce, remarriage, her love affair with Trotsky,
her hatred of the gringos, the amputation of her leg, her
probable suicide to escape the pain, her beauty, her
sensuality, her humour, her loneliness.

There's an excellent Mexican film about her, directed
by Paul Leduc Roseinweig. There's a beautiful novel by
Le Clezio called *Diego and Frida*. There's a fascinating
essay by Carlos Fuentes which introduces her Intimate
Diary. And there are numerous art historical texts pla-
cing her work in relation to Mexican popular art,

surrealism, communism, feminism. Yet I have just seen
something – something you can only really see if you
look at the paintings rather than the reproductions.
Maybe this thing is so simple, so obvious, that people
have taken it for granted. Anyway they don't talk about
it. And so here I am, writing.

A few of her paintings are on canvas, the vast majority
are either on metal or Masonite, which is as smooth as
metal. However fine the grain of a canvas, it resisted and
diverted her vision, making her brush strokes and the
contours she drew too painterly, too plastic, too public,
too epic, too much like (although still so different from)
the Elephant's work. For her vision to remain intact, she
needed to paint on a surface as smooth as skin.

Even on days when pain or illness forced her to stay in
bed, she spent hours every morning dressing and mak-
ing her toilette. Every morning, she said, I dress for
paradise! Easy to imagine her face in the mirror with her
dark eyebrows which naturally joined, and which with
her kohl crayon she emphasised and transformed into a
black bracket for her two indescribable eyes. (Eyes you
remember only if you shut your own!)

In a comparable way, when she painted her pictures, it
was *as if* she was drawing, painting or writing words on
her own skin. If this were to happen there would be a
double sensitivity, because the surface would also feel
what the hand was tracing – the nerves of both leading to
the same cerebral cortex. When Frida painted a self-
portrait with a little portrait of Diego painted on the skin

of her own forehead and on his forehead a painted eye, she was surely confessing – amongst other things – to this dream. With her small brushes, fine as eyelashes, and with her meticulous strokes, every image she made, as soon as she fully became the painter Frida Kahlo, aspired to the sensibility of her own skin. A sensibility sharpened by her desire and exacerbated by her pain.

The corporeal symbolism she used when painting body parts like the heart, uterus, mammary glands, spine, to express her feelings and ontological longing, has been noticed and commented upon many times. She did this as only a woman could, and as nobody else had done before. (Although Diego in his own way sometimes used a similar symbolism.) Yet it is essential to add here that, without her special method of painting, these symbols would have remained surrealist curiosities. And her special method of painting was to do with the sense of touch, with the *double* touch of hand and of surface as skin.

Look at the way she paints hairs, either those on the arms of her pet monkeys or her own along the hair-line of her forehead and temples. Each brush mark grows like a hair from a pore of the body's skin. Gesture and substance are one. In other paintings drops of milk being expressed from a nipple or drops of blood dripping from a wound, or tears flowing from her eyes, have the same corporeal identity – that is to say the drop of paint does not describe the body liquid but seems to be its double. In a picture called *Broken Column* her body is

pierced by nails and the spectator has the impression that she was holding the nails between her teeth and taking them one by one to tap in with a hammer. Such is the acute sense of touch which makes her painting unique.

And so we come to her paradox. How is it that a painter so concentrated on her own image is never narcissistic? People have tried to explain this by quoting Van Gogh or Rembrandt, who both painted numerous self-portraits. But the comparison is facile and false.

It is necessary to return to pain and the perspective in which Frida placed it, whenever it allowed her a little respite. The capacity to feel pain is, her art laments, the first condition of being sentient. The sensitivity of her own mutilated body made her aware of the skin of everything alive – trees, fruit, water, birds and – naturally – other women and men. And so, in painting her own image, as if on her skin, she speaks of the whole sentient world.

Critics say that Francis Bacon's work was concerned with pain. In his art, however, pain is being watched through a screen, like soiled linen being watched through the round window of a washing machine. Frida Kahlo's work is the opposite of Francis Bacon's. There is no screen; she is close-up, proceeding with her delicate fingers, stitch by stitch, making not a dress, but closing a wound. Her art talks to pain, mouth pressed to the skin of pain, and it talks about sentience and its desire and its cruelty and its intimate nicknames.

One finds a comparable intimacy with pain in the poetry of the great living Argentinian poet, Juan Gelman.

that woman begs for alms in a twilight of pots and
 pans
that she's washing furiously / with blood / with
oblivion / to ignite her is like putting a gardel record
 on the phonograph /
streets of fire fall from her unbreakable *barrio* /

and a man and a woman walking tied
to the apron of pain we put on to wash /
like my mother washing the floors every day /
and the day would have a little pearl at its feet.*

Much of Gelman's poetry has been written in exile during the 1970s and 1980s, and much of it is about the *compañeros* – including his son and daughter-in-law whom the Junta made *disappear*. It is a poetry in which the martyred come back to share the pain of those bereaving them. Its time is outside time, in a place where pains meet and dance and those suffering grief make their assignations with their losses. Future and past are excluded there as absurd; there is only the present, only the immense modesty of the present which claims everything ever, except lies.

* From 'Cherries (to Elizabeth)'. Juan Gelman, *Unthinkable Tenderness,* translated from the Spanish by Joan Lindgren (University of California Press, 1997).

Often the lines of Gelman's poems are punctuated by strokes, which somewhat resemble the beat of the tango – the music of Buenos Aires, his city. But the strokes are also silences which refuse entry to any lie. (They are the visible antithesis to censorship which is invariably imposed in order to defend a system of lies.) They are a reminder of what pain discovers and even pain cannot say.

did you hear me / heart? / we're taking
defeat someplace else /
we're taking this animal elsewhere
our dead / somewhere else /

let them make no noise / quiet as they can be / not
even the silence of their bones should be heard /
their bones, little blue-eyed animals /
who sit like good children at table /

who touch pain without meaning to /
saying not a word about their bullet wounds /
with a little gold star and a moon in their mouths /
appearing in the mouths of those they loved*

This poetry helps us see something else about Kahlo's paintings, something that separates them distinctly from Rivera's, or any of her Mexican contemporaries. Rivera

* From 'Somewhere Else', Juan Gelman, ibid.

placed his figures in a space which he had mastered and which belonged to the future; he placed them there like monuments: they were painted for the future. And the future (although not the one he imagined) has come and gone and the figures have been left behind alone. In Kahlo's paintings there was no future, only an immensely modest present which claimed everything and to which the things painted momentarily return whilst we look, things which were already memories before they were painted, memories of the skin.

So we return to the simple act of Frida putting pigment on the smooth surfaces she chose to paint on. Lying in bed or cramped in her chair, a minute brush in her hand, which had a ring on every finger, she remembered what she had touched, what was there when the pain wasn't. She painted, for example, the feel of polished wood on a parquet floor, the texture of rubber on the tyre of her wheelchair, the fluff of a chick's feathers, or the crystalline surface of a stone, like nobody else. And this discreet capacity – for it was very discreet – came from what I have called the sense of double touch: the consequence of imagining she was painting her own skin.

There's a self-portrait (1943) where she lies on a rocky landscape and a plant grows out of her body, her veins joining with the veins of its leaves. Behind her, flattish rocks extend to the horizon, a little like the waves of a petrified sea. Yet what the rocks are *exactly* like is what she would have felt on the skin of her back and legs if she

had been lying on those rocks. Frida Kahlo lay cheek to cheek with everything she depicted.

That she became a world legend is in part due to the fact that in the dark age in which we are living under the new world order, the sharing of pain is one of the essential preconditions for a refinding of dignity and hope. Much pain is unshareable. But the will to share pain is shareable. And from that inevitably inadequate sharing comes a resistance.

Listen again to Gelman:

hope fails us often
grief, never.
that's why some think
that known grief is better
than unknown grief.
they believe that hope is illusion.
they are deluded by grief.*

Kahlo was not deluded. Across her last painting, just before she died, she wrote Viva La Vida.

* From 'The Deluded', Juan Gelman, ibid.

18

A Bed

(for Christoph Hänsli)

On the hotel bed there is no body, nor on the bed beside it. In the English language the situation can be condensed into one word: *no body* becomes *nobody*. One cannot ask: Who is nobody? Or maybe one can ask (as the water pipes in the next room gurgle) but no answer will come.

Nobody is nobody and both beds are empty. There is not even a crease, a trace. There is nobody.

Nobody is your beloved or mine, and nobody is every couple who once occupied this room. Over the years they add up to thousands. They lay sleepless. They made love. They sprawled over the two beds pulled together. They pressed tight against one another in one twin bed. They went home next day or they never met again. They made money or lost it. They betrayed one another. They saved each other.

Nobody is here and the beds in all their anonymity are empty. Or I might say: full of absence, but this suggests a sentimentality, a regret, which your paintings do not allow.

Yet simply because we have lived, we cannot forget as we stand in front of your canvases – and they are life-size – we cannot forget, and you do not want us to forget, what beds promise. Beds promise more than any other man-made object. They promise like nature does when benign. Perhaps this is why beds are so hard to paint?

167

Even in this one-star hotel with cheap synthetic sheets the beds promise like nature does.

The range of their promise is huge, from the modest to the voluptuous, from the timid to the ecstatic, from a pain's small relief to the great pain of happiness, from a little rest to death.

No wonder that in hotel wardrobes there's often a card to hang on the door handle, which says: DO NOT DISTURB.

And no wonder, Christoph, that you paint, whilst not changing anything, whilst following the example of Velázquez, that you paint these bedroom walls, papered or painted, as if they were infinite. Infinite like the sky or the sea? No. Not at all. Infinite like promise. Even a bed's smallest promise partakes of infinity . . . Sleep.

Sleep. You are awake and painting, but we, lulled and half asleep, whisper unaccountably and recklessly to the absence: Come, my heart, I'm here, and we whisper this to nobody.

One of your canvases is about such a whisper. It's of an unmade bed and a crumpled duvet. The infinite wall is behind. For centuries painted sheets and draperies have featured in European art. Danaë reclines upon them. The body of the dead Christ is laid out on them. They receive the marvellous body and are moulded by it. But here there are only the traces, only an absence.

I was here. And now I too have left. There is nobody.

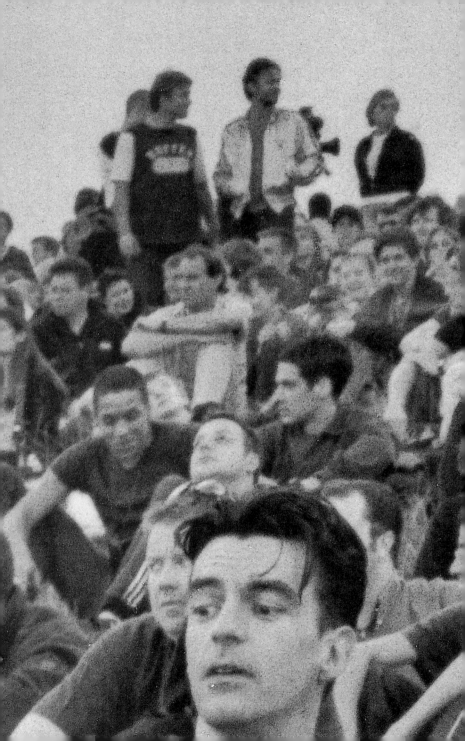

19

A Man with Tousled Hair

During that winter walking around the centre of Paris I couldn't stop thinking about a portrait. It's of an unknown man and was painted some time in the early 20s of the nineteenth century. The portrait was the image on the posters, at every street corner, announcing a large Géricault exhibition at the Grand Palais.

The painting in question was discovered in an attic in Germany, along with four other similar canvases, forty years after Géricault's early death. Soon afterwards it was offered to the Louvre who refused it. Imagined in the context of the denunciation and drama of the *Raft of the Medusa*, which had already been hanging in the museum for forty years, the offered portrait would at that time have had a nondescript air. Yet now it has been chosen to represent the same painter's entire *oeuvre*. What changed? Why has this frail portrait become today so eloquent, or, more precisely, so haunting?

Behind everything that Géricault imagined and painted – from his wild horses to the beggars he recorded in London – one senses the same vow: Let me face the affliction, let me discover respect and, if possible, find a beauty! Naturally the beauty he hoped to find meant turning his back on most official pieties.

He had much in common with Pasolini:

I force myself to understand everything,
ignorant as I am of any life that isn't
mine, till, desperate in my nostalgia,

I realise the full experience
of another life; I'm all compassion,
but I wish the road of my love for

this reality would be different, that I
then would love individuals, one by one.

The portrait on the poster was once entitled *The Mad Murderer*, later, *The Kleptomaniac*. Today it is catalogued as *The Monomaniac of Stealing*. Nobody any longer knows the man's proper name.

The sitter was an inmate of the asylum of La Salpétrière in the centre of Paris. Géricault painted there ten portraits of people certified as insane. Five of these canvases survived. Among them is another unforgettable one of a woman. In the museum of Lyon, it was originally entitled *The Hyena of the Salpétrière*. Today she is known as *The Monomaniac of Envy*.

Exactly why Géricault painted these patients we can only guess. Yet the way he painted them makes it clear that the last thing he was concerned with was the clinical label. His very brush marks indicate he knew and thought of them by their names. The names of their souls. The names which are no longer known.

A decade or two earlier, Goya had painted scenes of

incarcerated mad people, chained and naked. For Goya, however, it was their acts that counted, not their interiority. Before Géricault painted his sitters in La Salpétrière perhaps nobody, neither painter, nor doctor, nor kith, nor kin, had ever looked for so long and so hard into the face of someone categorised and condemned as mad.

In 1942 Simone Weil wrote: 'Love for our neighbour, being made of creative attention, is analogous to genius.' When she wrote this she was certainly not thinking about art.

The love of our neighbour in all its fullness simply means being able to say to him: 'What are you going through?' It is a recognition that the sufferer exists, not only as a unit in a collection, or a specimen from the social category labelled 'unfortunate', but as a man, exactly like we are, who was one day stamped with a special mark of affliction. For this reason it is enough, but it is indispensable to know how to look at him in a certain way.

For me, Géricault's portrait of the man with tousled hair and disarranged collar and with eyes which no guardian angel protects, demonstrates the 'creative attention' and contains the 'genius' to which Simone Weil refers.

Yet why was this painting so haunting in the streets of Paris? It pinched us between two fingers. I will try to explain the first finger.

There are many forms of madness which start as

theatre. (As Shakespeare, Pirandello and Artaud knew so well.) Folly tests its strength in rehearsals. Anyone who has been beside a friend beginning to fall into madness will recognise this sense of being forced to become an audience. What one sees at first on the stage is a man or a woman, alone, and beside them – like a phantom – the inadequacy of all given explanations to explain the everyday pain being suffered. Then he or she approaches the phantom and confronts the terrible space existing between spoken words and what they are meant to mean. In fact this space, this vacuum, *is* the pain. And finally, because like nature it abhors a vacuum, madness rushes in and fills the space and there is no longer any distinction between stage and world, playing and suffering.

Between the experience of living a normal life at this moment on the planet and the public narratives being offered to give a sense to that life, the empty space, the gap, is enormous. The desolation lies *there*, not in the facts. This is why a third of the French population are ready to listen to Le Pen. The story he tells – evil as it is – seems closer to what is happening in the streets. Differently, this is also why people dream of 'virtual reality'. Anything – from demagogy to manufactured onanistic dreams – anything, anything, to close the gap! In such gaps people get lost, and in such gaps people go mad.

In all five of the portraits Géricault painted in La Salpétrière the sitters' eyes are looking elsewhere, askance. Not because they are focused on something

distant or imagined, but because, by now, they habitually avoid looking at what is near. What is near provokes a vertigo because it is inexplicable according to the explanations offered.

How often today can one encounter a not dissimilar glance refusing to focus on the near – in trains, parking lots, bus queues, shopping precincts . . .

There are historical periods when madness appears to be what it is: a rare and abnormal affliction. There are other periods – like the one we have just entered – when madness appears to be typical.

All this describes the first of the two fingers with which the image of the man with tousled hair pinched us. The second finger comes from the compassion of the image.

Post-modernism is not usually applied to compassion. It might be both useful and humbling to apply it.

Most revolts in history were made to restore a justice which had been long abused or forgotten. The French Revolution, however, proclaimed the world principle of a Better Future. From that moment onwards all political parties of both left and right were obliged to make a promise which maintained that the amount of suffering in the world was being and would be reduced. Thus all affliction became, to some degree, a reminder of a hope. Any pain witnessed, shared or suffered remained of course pain, but could be partly transcended by being felt as a spur towards making greater efforts for a future where that pain would not exist. Affliction

had an historical outlet! And, during these two tragic centuries, even tragedy was thought of as carrying a promise.

Today the promises have become barren. To connect this barrenness solely with the defeat of communism is short-sighted. More far-reaching are the ongoing processes by which commodities have replaced the future as a vehicle of hope. A hope which inevitably proves barren for its clients, and which, by an inexorable economic logic, excludes the global majority. To buy a ticket for this year's Paris–Dakar Rally to give to the man with tousled hair makes us madder than he.

So we face him today without an historical or a modern hope. Rather we see him as a consequence. And this, by the natural order of things, means we see him with indifference. We don't know him. He's mad. He's been dead for more than a hundred and fifty years. Each day in Brazil a thousand children die of malnutrition or illnesses which in Europe are curable. They're thousands of miles away. You can do nothing.

The image pinched. In it there is a compassion that refutes indifference and is irreconcilable with any easy hope.

To what an extraordinary moment this painting belongs in the history of human representation and awareness! Before it, no stranger would have looked so hard and with such pity at a lunatic. A little later and no painter would have painted such a portrait without

exhorting a glimmer of a modern or romantic hope. Like Antigone's, the lucid compassion of this portrait coexists with its powerlessness. And those two qualities, far from being contradictory, affirm one another in a way that victims can acknowledge but only the heart can recognise.

This, however, should not prevent us from being clear. Compassion has no place in the natural order of the world, which operates on the basis of necessity. The laws of necessity are as unexceptional as the laws of gravitation. The human faculty of compassion opposes this order and is therefore best thought of as being in some way supernatural. To forget oneself, however briefly, to identify with a stranger to the point of fully recognising her or him, is to defy necessity, and in this defiance, even if small and quiet and even if measuring only 60cm. × 50cm., there is a power which cannot be measured by the limits of the natural order. It is not a means and it has no end. The Ancients knew this.

'I did not think,' said Antigone, 'your edicts strong
 enough
To overrule the unwritten unalterable laws
Of God and heaven, you being only a man.
They are not of yesterday or today, but everlasting,
Though where they came from, none of us can tell.'

The poster looked down on the streets of Paris as might a ghost. Not the ghost of the man with tousled hair, nor

Géricault's. But the ghost of a special form of attention, which for two centuries had been marginalised but which every day now was becoming less obsolete. This is the second finger.

Pinched, what do we do? Wake up perhaps.

20

An Apple Orchard

(An Open Letter to Raymond Barre, Mayor of Lyon)

Monsieur Le Maire,

I have been asked to write to you whilst you are dreaming. Not an easy task. Dreams proceed in their own way, have their own manner of jumping and side-stepping and throwing the dreamer (why in English are nightmares called night*mares*?), dreams have their own predilection for not saying things, their own form of mystery, and their own intimate and inexplicable relation with what may be true. On the one hand I have to tread carefully so as not to wake you up, and, on the other hand, I have to avoid straight lines, otherwise you will stop dreaming. In a dream nothing is insignificant.

The prison of St Joseph was built in Lyon between 1829 and 1831. It faces the River Rhône just before it is joined by the Soane.

Forty years later, the second prison of St Paul was built beside St Joseph's. Hexagonal in form and using new construction techniques with metal, St Paul's was planned for women. It had four long dormitories instead of cells.

Today, the two buildings, connected by an underground tunnel, serve as the city's principal Maison d'Arrêt for prisoners awaiting trial or serving short

sentences. Where the dormitories once were, cells have been installed. The prison complex is known today, by those who are familiar with it, as La Marmite du Diable. The Devil's Cauldron.

Most theories about, or visions concerning, prisons tend to be false, because the practice defies everything, or anything, which has been thought out. The containment, the way the spaces are interlocked, the hours, the codes, the isolation and the overcrowding – these things together produce the unpredictable, before which some inmates are more vulnerable than others, but before which all who find themselves there, inside – including the warders and even the Director – are, at certain moments, powerless.

Prisons are planned and manned in such a way that supervision – electronic and otherwise – maintains a maximum control over the imprisoned at all times. Yet in practice the uncontrollable is constantly present. There is no other institution on earth where the uncontrollable can explode so quickly.

On the far side of desperation, men become either wise or beyond control, beyond the control of any system or of themselves. The uncontrollable is incarcerated in the same cell as wisdom, behind the same door of desperation.

Sometimes the uncontrollability enters a prisoner's own body. It is this which 'explains' the frequent cases of self-mutilation. Men damage themselves because the

prison and its uncontrollability have already penetrated their bodies. Nothing stops nothing. The mutilation is not to the self, but to what has penetrated that self before the swallowed spoon, the swallowed broken glass, the swallowed knife.

Who was Delandine? Perhaps it was a nickname. What is certain is that there's a street named after her, the narrow short street which separates the two prisons.

After midnight and at weekends the Rue Delandine, which in the daytime is usually deserted, is full of people who have come to talk, to fling words over the high walls, to their prisoners inside. Certain shouts come back like boomerangs. I love you too! At another window: Why don't you fuck off and let me be!

The visitors come to the Rue Delandine after midnight because the noise of the city traffic has diminished by then, and it's easier to hear and be heard. On Monday nights there's often nobody there. On Mondays the silent street becomes full of something else. Stay dreaming, sir, and you may feel it. Behind the walls, across the narrowest gully, and then very close behind the second walls, on both left and right, there is a sense of stacked sleep, and, confronting that sleep, almost touching it, the total indifference of the hewn stones, iron bars, and laid bricks. A strange congruity, even harsher than that of the earth around corpses.

What kind of building would you say, sir, houses the most dreams? School? Theatre? Cinema? Library?

Intercontinental Hotel? Discothèque? Mightn't it be a prison?

First, the modern prison was founded on a set of dreams. The dream of Civic Justice. The dream of Correction. The dream of a City of Civic Virtue.

And then there are the dreams dreamt now, each night. Dreams include, of course, nightmares and insomniac terrors. Under certain circumstances the insomniac may lose, like a dreamer, his sense of physical time and place.

Inside the walls, on the other side of the narrow gullies, there is the great perennial dream of Escape. Amongst the screws there is the perennial nightmare of a Prisoners' Revolt.

Further, there are the endless small dreams. The dream of the sea – the Rhône is the length of a garden away and the pigeons, who shit on the wire netting, fly over the river. The dream of taking the TGV to Paris. It leaves every hour and its tracks are even nearer than the Rhône. Dreams of privacy. These are as much about time as space. The dream of private time. Choosing a date – say Saturday May 6th – to do something one has chosen for oneself! On Saturday, I'll go and see the brother-in-law in Bapaume. Or, on Saturday, I'll go to the cemetery in Clamart and there I'll find the vodka bottle under the flowers on my friend's grave and I'll drink to him. (He too was in another kind of prison for twenty-seven years.)

The dream of women. The dream of open doors. The

dream of Saturday nights. The furious dream of putting an end to everything. The dream of no more mistakes.

And, finally, there is a dream which may be the most persistent and ubiquitous of all. In St Joseph's isolation block, in the *prétoire* where punishments for insubordination are handed out twice a week, in the showers, in the exercise yard under the wire netting with garbage where the stars might be, walking on all fours, sitting before the television, on the stairs, in the *mitard*, alternating between insults and silence, day and night, year after year, men dream in flashes of their thousand mothers, many of whom are lost or dead and, who being so, find their own way instantaneously through the prison walls.

Once inside the Maison d'Arrêt, some of these mothers tell stories to their children. Many many stories. Here, sir, is one.

Once there was a man who, every morning, picked up a bread-knife and cut off ten centimetres from the loaf of bread he was holding, and threw this chunk away, before cutting another slice for his own breakfast.

The man did this because every night mice had nibbled a hole from the centre of the loaf. Each morning the hole was about the size of a mouse. The house cats, although they hunted moles, were strangely indifferent to the grey mice who ate the bread, or perhaps they had been bought off.

This had been the state of affairs for months. Many

times the man had written down *mousetrap* on a shopping list. And many times he had forgotten, perhaps because the shop where the villagers once bought mousetraps no longer existed.

One afternoon this man is searching in a shed beside the house for a metal file. He doesn't find a file, but he comes upon a strong, obviously handmade, mousetrap. It consists of a plank of wood, 18cm. × 9cm., with a cage around it made of stout wire. The space between any two parallel wires is never more than half a centimetre. Enough for a mouse to poke its nose through but never enough to get its two ears through. The height of the cage is 8.5cm., so that, inside, a mouse can stand up on its strong hind legs, clutch the bars at the top with its four-fingered hands, and poke its snout between the wires of the ceiling, but it can never get out.

One end of the cage is a door which hinges upwards. A spiral spring is attached to this door. When the door is held open, the spring goes taut, ready to pull it back shut.

On top of the cage is a trip wire which fastens the door when open. The trip wire, however, extends beyond the doorframe by less than a millimetre. In wire-terms by a hair's breadth! At the other end of the wire, inside the cage, is a hook on to which a piece of cheese or raw liver is fixed.

The mouse enters the cage to take a bite. No sooner does he touch the morsel with his teeth, than the trip wire releases the door and it slams shut behind him, before he can turn his head.

It takes the mouse several hours to realise that he is a prisoner, unhurt, in a cage measuring 18cm. by 9cm. After that, something in him never stops trembling.

The man takes the mousetrap into the house. He tests it. He fixes a lump of cheese on to the hook and places the trap on the shelf in the cupboard where the bread is kept.

Next morning the man finds a grey mouse in the cage. The cheese in the cage is untouched. Since the door was shut, the mouse lost his appetite. When the man picks up the cage, the mouse tries to hide behind the spring attached to the door. The mouse has jet black eyes which stare without blinking. The man places the cage on the kitchen table. The longer he looks into the cage, the more clearly he sees a resemblance between the sitting mouse and a kangaroo. There is a silence. The mouse becomes a little calmer. Then the mouse begins to circle the cage, testing again and again with one of his fingered forepaws the space between the wires, searching for an exception. The mouse tries biting the wires with his teeth. Then he sits back on his haunches, paws to his mouth. Rarely does somebody look at a mouse as long as the man does. Or vice versa.

The story is interrupted by voices from the Rue Delandine.

Tell Alex he has to send money.

I did.

Tell him if he doesn't, he'll burn.

I can't hear you.
He'll burn.

The man takes the cage to a field outside the village, places it on the grass and opens the door. It takes the mouse a minute to realise the fourth wall has disappeared. He tests the open space with his muzzle. Then he darts out, and scuttles to the nearest tuft of grass where he hides.

I'll wait for you, Jacko. I love you, Jacko, I love you. However long, Jacko, I'm waiting.

The next day the man finds another mouse in the cage. He's heavier than the first, but more agitated. Perhaps he is older. The man puts the cage on the floor and sits on the floor himself to watch. The mouse climbs on to the wires of the ceiling and holds himself there upside down.

Forgive me, Toni, can you hear me? Forgive me!

When the man opens the cage in the field, the old mouse runs away in a zig-zag line until he's out of sight.

One morning the man finds two mice in the cage. It's hard to say how much they are aware of each other, or to guess whether the presence of the other lessens or increases their mutual fear. One has larger ears, the other glossier hair. Mice resemble kangaroos because of

the relatively enormous force of their hind legs, and the way their strong tails press against the ground for leverage when they leap.

Need to get a message to Jo-Jo.

Jo-Jo asks how you're doing, Lenuta.

Tell him I'll be working the lorry route from Warsaw next month if things don't take a turn for the better.

Not good news.

Tell him he didn't leave me much choice.

Take a pistol in your bag, Lenuta.

Tell him old peasant women sell blueberries along the same lorry route!

Don't trust the Russians.

He's crazy. That's why he's inside. Jo-Jo is crazy.

Lenuta!

In the field, when the man lifts the fourth wall, the two mice do not hesitate. They leave immediately, side by side, and take opposite directions, one going east and the other west.

Gilles! Can you hear me? Gilles, tell me if you can hear me. Gilles, I sent you a parcel today with all the grub you listed. Plus the mint chocolate you like . . .

Scarcely any bread in the cupboard has been eaten. The mouse, when the man picks up the cage, reacts with the usual panic, but moves more heavily. The man leaves the

kitchen to take his mail and to chat for a moment with the postman. When he returns, there are nine newly born mice in the cage. Perfectly formed. Pink. Each one twice the size of a grain of long rice.

No, sir, do not wake up. Do not be disturbed. Remember this story is being told by a mother. Listen to her in your dream.

After ten days, the man asks himself whether some of the mice he has released in the field are not returning to the house. He decides, on reflection, that this is unlikely. He observes each one so closely that he is convinced that, should one return, he would recognise her or him immediately.

Harry! It's me! I couldn't come on Wednesday. Harry, I'm here tonight!

Harry asked me to tell you if you came. He's been transferred to the hospital. He didn't want to go. They took Harry to the hospital, chained his legs and took him.

The mouse in the cage holds his head on one side as if he was wearing a cap. His two front paws, with their four fingers, are planted firmly on the ground either side of his muzzle, like the hands of a pianist on a keyboard. His hind legs are tucked in close and extend along the ground so that they are almost under his ears. His ears are perked up, and his tail, stretched out far behind him, is pressed firmly on the floor of the cage. His heart's beating very fast and he is frightened when the man lifts

up the cage. Yet he doesn't hide behind the spring; he doesn't cringe. He holds his head acock, and he stares back. For the first time, a name for the mouse comes into the man's head. Alfredo, he calls him. He puts the cage on the kitchen table beside his coffee cup.

Later the man goes to the field, kneels down, places the cage on the grass and holds the door, which is the fourth wall of the cell, open. The mouse approaches the open wall, raises his head, and leaps. He does not scuttle, he does not dart, he flies. Relative to his size, he leaps higher and further than a kangaroo. He leaps like a mouse who has been freed. With three leaps he has covered more than five metres. And the man, still on his knees, watches the mouse he called Alfredo leap again and again into the sky.

We're going to begin again, honey, begin from scratch.

The following morning the bread has not been touched. And the man believes the mouse in the cage may be the last one. Kneeling in the field outside the village, holding the door open, the man waits. It takes the mouse a long while to realise he can leave. When he finally does, he scuttles into the thickest and nearest tuft of grass, and the man feels a slight yet sharp pang of disappointment. He had been hoping to see, one more time in his life, a prisoner fly, a prisoner realise his dream of freedom. He had hoped that there would be another Alfredo.

*　　*　　*

Monsieur le Maire, you are, I trust, still dreaming. The first step, if I understand it well, in your extensive plan for the rebuilding of the centre of Lyon (the plan to which you gave the magical name of Confluence), is the demolition of the prisons of St Joseph and St Paul.

What will take their place? I would like to make a suggestion. The area the two prisons cover is small. Less than two hectares. Imagine this site turned into an apple orchard, being used and enjoyed as a public park. It would be the first apple orchard in the heart of a city in the entire world! And the blossoms in the spring, and the fruit in late October, would be a memorial to all the dreams dreamt here. Here, if I may emphasise that word, sir, *Here*.

Recently I went, sir, to see my friend Zima Lewandowski near Zamosc, not far from the Ukrainian border. He is one of the great forestry experts in Poland; he discovered a new way of dating trees. Forests form a script and their experts can sometimes be a little like etymologists. Zima when he speaks has that kind of precision. I told him about our project – the project you are dreaming, sir – concerning an apple orchard in the centre of Lyon, and I asked his advice about what species of fruit would be best. He thought for a while, asked me questions about the climate and atmospheric conditions in the city, and then said: Spartans! Spartans would be the best apples there. They are a late apple, you pick them in October, and, if kept properly, they last the whole winter.

The Park, sir, could be called Delandine's Orchard, no? As for the Spartan apples, when they are ripe, they are a smoky red, almost like the colour of a mineral dug out of the earth. The trees should be planted, according to Zima, 6 or 8m. apart. The present cells measure 3m. × 3.6m.

21

Brushes Standing Up in Jars

One of his recent paintings is called *The Eel*. It shows a painter's studio, brushes standing up in jars, a long slender woman reclining naked, and an eel in a bowl surrounded by drawings on a table. When eels on dry land want to escape from the sun or to hide, they use their tails like corkscrews, make a hole in the earth and disappear tail-first. Some of his other paintings are of holes, rather like those made by eels.

Another one of his titles is *La Déluge*, and in *L'Amour Fou* the sea invades a library. He's an aquatic painter. Even when he depicts the African desert, he makes you aware that once, aeons or a few seconds ago, the white surface was flattened and pulverised by water.

In his art, as on the earth, a flood is both an abundance and a calamity, a deliverance and a death, a beginning and an end.

In 1994 Miquel Barceló wrote the following in one of his notebooks:

To paint a flayed ox has rebecome important. Like in other times but always different. Not like the Romans painted food, not like Rembrandt, not like Soutine or Bacon, not like Beuys – suddenly the chance to paint this has become something urgent, necessary, essen-

tial: blood and sacrifice . . . but it would work also with an apple, with a face . . . one has to take things, one after another, from the stickiness of Berlusconi, and make them anew, fresh and clean, show them palpitating, or with their own sweet rottenness.

The reference to Berlusconi is telling. Every day, all over the world, the media network replaces reality with lies. Not, in the first place, political or ideological lies (they come later), but visual, substantial lies about what human and natural life is actually made of. All the lies converge into one colossal falsehood: the supposition that life itself is a commodity and that those who can afford to buy it are, by definition, those who deserve it! Most of us know this is false, but very little of what we are shown confirms our resistance. Then we may come upon a painting by Barceló.

Imagine, suddenly, the substantial material world (tomatoes, rain, birds, stones, melons, fish, eels, termites, mothers, dogs, mildew, salt water) in revolt against the endless stream of images which tell lies about them and in which they are imprisoned! Imagine them, as a reaction, claiming their freedom from all grammatical, digital and pictorial manipulation, imagine an uprising of the represented!

This is what is happening on these canvases. They are listening to the revolt of the solid and the mortal. Before the deluge of insubstantial consumerist clichés and the claim that the genius of mankind is to be found in the

pursuit of profit, they open a floodgate to the elemental flow of life and death.

Ecological propaganda, however, is no better than any other propaganda when it comes to producing art. And so the secret of these paintings is not in their argument but in the way they listen. They listen to the protest of each thing painted against being so depicted, which means also against being recuperated and used as a lie. They listen and the protests become visual for they are nervously translated into pictorial language.

Let me list some of the ploys the protests use and the art of painting interprets. There is the ploy against being framed: the things being painted desert the centre and go to the edges.

There is the refusal to be reduced to a patch of colour: the thing being painted heaves itself up into a three-dimensional lump, or scoops out its hollow inside so that if the canvas was on the floor you could stand a spoon up in it.

There is the rejection by the thing being painted of cheap labels: a blue fish cuts itself up into nine pieces and deploys itself across the whole terrain of the picture.

There is the sabotage of the things being painted against anything which is suave and pretends to be complete: painted bodies of flesh stuff themselves with fibres and hair.

And then there are the continual plots by what is being painted against any uniform space or perspective: things become a mirage, a sky is being stirred like soup,

or surfaces of the earth under rain seem as flimsy as a smear across a window.

Nothing he paints wants to give up its soul and become simply an image. And he goes along with this. 'I need to have what I am painting beside me, *on* the painting, smelling it, handling it. And then eating it. Using melon rinds as spatulas when I am painting melons, and so mixing their juice with the paint.'

This could all lead to incoherence, the risk is considerable, and he enjoys the risk. Yet the work remains coherent. I cannot explain why, any more than I can explain why a swarm of bees always has a kind of symmetry.

I think about Chaim Soutine, not to make an art-historical comparison, but because, by imagining the two painters side by side, I see more clearly what has changed in the world during the last fifty years. Soutine, too, listened intently to the will of what he was painting, and, as a result, his art is full of pathos and suffering. In Barceló there is no pathos; there is simply the will of the teeming, pullulating material of the universe to resist! And in this resistance is hope. A hope that we are desperately trying to learn to recognise.

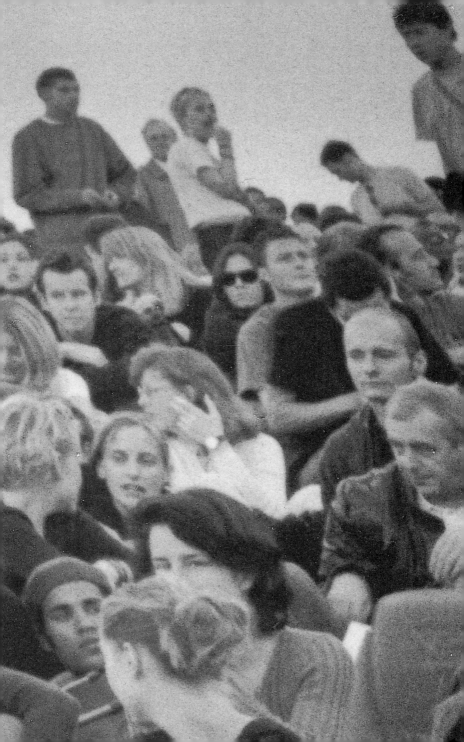

22

Against the Great Defeat of the World

In the history of painting one can sometimes find strange prophecies. Prophecies that were not intended as such by the painter. It is almost as if the visible by itself can have its own nightmares. For example, in Brueghel's *Triumph of Death*, painted in the 1560s and now in the Prado Museum, there is already a terrible prophecy of the Nazi extermination camps.

Most prophecies, when specific, are bound to be bad, for, throughout history, there are always new terrors – even if a few disappear, yet there are no new happinesses – happiness is always the old one. It is the modes of struggle for this happiness which change.

Half a century before Brueghel, Hieronymus Bosch painted his *Millennium Triptych*, which is also in the Prado. The left-hand panel of the triptych shows Adam and Eve in Paradise, the large central panel describes the Garden of Earthly Delights, and the right-hand panel depicts Hell. And this hell has become a strange prophecy of the mental climate imposed on the world at the end of our century by globalisation and the new economic order.

Let me try to explain how. It has little to do with the symbolism employed in the painting. Bosch's symbols probably came from the secret, proverbial, heretical

language of certain fifteenth-century millennial sects, who heretically believed that, if evil could be overcome, it was possible to build heaven on earth! Many essays have been written about the allegories to be found in his work.* Yet if Bosch's vision of hell is prophetic, the prophecy is not so much in the details – haunting and grotesque as they are – but in the whole. Or, to put it another way, in what constitutes the *space* of hell.

There is no horizon there. There is no continuity between actions, there are no pauses, no paths, no pattern, no past and no future. There is only the clamour of the disparate, fragmentary present. Everywhere there are surprises and sensations, yet nowhere is there any outcome. Nothing flows through: everything interrupts. There is a kind of spatial delirium.

Compare this space to what one sees in the average publicity slot, or in a typical CNN news bulletin, or any mass media news commentary. There is a comparable incoherence, a comparable wilderness of separate excitements, a similar frenzy.

Bosch's prophecy was of the world-picture which is communicated to us today by the media under the impact of globalisation, with its delinquent need to sell incessantly. Both are like a puzzle whose wretched pieces do not fit together.

And this was precisely the term that the Subcomandante Marcos used in a letter about the new world order

* One of the most original, even if contested, is the *Millennium of Hieronymus Bosch* by Wilhelm Franger (Faber & Faber).

last year . . . He was writing from the Chiapas, south-east Mexico.* He sees the planet today as the battlefield of a Fourth World War. (The Third was the so-called Cold War.) The aim of the belligerents is the conquest of the entire world through the market. The arsenals are financial; there are nevertheless millions of people being maimed or killed every moment. The aim of those waging the war is to rule the world from new, abstract power centres – megapoles of the market, which will be subject to no control except that of the logic of invest-ment. Meanwhile nine-tenths of the women and men living on the planet live with the jagged pieces that do not fit.

The jaggedness in Bosch's panel is so similar that I half expect to find there the seven pieces that Marcos named.

The first piece he named has a dollar sign on it and is green. The piece consists of the new concentration of global wealth in fewer and fewer hands and the unpre-cedented extension of hopeless poverties.

The second piece is triangular and consists of a lie. The new order claims to rationalise and modernise production and human endeavour. In reality it is a return to the barbarism of the beginnings of the in-dustrial revolution, with the important difference this time round that the barbarism is unchecked by any opposing ethical consideration or principle. The new

* This letter was published in August 1997 throughout the world press, and notably in *Le Monde Diplomatique*, Paris.

order is fanatical and totalitarian. (Within its own system there are no appeals. Its totalitarianism does not concern politics – which, by its reckoning, have been superseded – but global monetary control.) Consider the children. One hundred million in the world live in the street. Two hundred million are engaged in the global labour force.

The third piece is round like a vicious circle. It consists of enforced emigration. The more enterprising of those who have nothing try to emigrate to survive. Yet the new order works night and day according to the principle that anybody who does not produce, who does not consume, and who has no money to put into a bank, is redundant. So the emigrants, the landless, the homeless are treated as the waste matter of the system: to be eliminated.

The fourth piece is rectangular like a mirror. It consists of an ongoing exchange between the commercial banks and the world racketeers, for crime too has been globalised.

The fifth piece is more or less a pentagon. It consists of physical repression. The Nation States under the new order have lost their economic independence, their political initiative and their sovereignty. (The new rhetoric of most politicians is an attempt to disguise their political, as distinct from civic or repressive, powerlessness.) The new task of the Nation States is to manage what is allotted to them, to protect the interests of the market's mega-enterprises and, above all, to control and police the redundant.

The sixth piece is the shape of a scribble and consists of breakages. On one hand, the new order does away with frontiers and distances by the instantaneous tele-communication of exchanges and deals, by obligatory free trade zones (NAFTA), and by the imposition every-where of the single unquestionable law of the market; and on the other hand, it provokes fragmentation and the *proliferation* of frontiers by its undermining of the Nation State – for example, the former Soviet Union, Yugoslavia, etc. 'A world of broken mirrors,' wrote Marcos, 'reflecting the useless unity of the neoliberal puzzle.'

The seventh piece of the puzzle has the shape of a pocket, and consists of all the various pockets of resis-tance against the new order which are developing across the globe. The Zapatistas in south-east Mexico are one such pocket. Others, in different circumstances, have not necessarily chosen armed resistance. The many pockets do not have a common political pro-gramme as such. How could they, existing as they do in the broken puzzle? Yet their heterogeneity may be a promise. What they have in common is their defence of the redundant, the next-to-be-eliminated, and their belief that the Fourth World War is a crime against humanity.

The seven pieces will never fit together to make any sense. This lack of sense, this absurdity is endemic to the new order. As Bosch foresaw in his vision of hell, there is no horizon. The world is burning. Every figure is trying

to survive by concentrating on his own immediate need and survival. Claustrophobia, at its most extreme, is not caused by overcrowding, but by the lack of any continuity existing between one action and the next that is close enough to be touching it. It is this that is hell.

The culture in which we live is perhaps the most claustrophobic that has ever existed; in the culture of globalisation, as in Bosch's hell, there is no glimpse of an *elsewhere* or an *otherwise*. The given is a prison. And faced with such reductionism, human intelligence is reduced to greed.

Marcos ended his letter by saying: 'It is necessary to build a new world, a world capable of containing many worlds, capable of containing all worlds.'

What the painting by Bosch does is to remind us – if prophecies can be called reminders – that the first step towards building an alternative world has to be a refusal of the world-picture implanted in our minds and all the false promises used everywhere to justify and idealise the delinquent and insatiable need to sell. Another space is vitally necessary.

First, an horizon has to be discovered. And for this we have to refind hope – against all the odds of what the new order pretends and perpetrates.

Hope, however, is an act of faith and has to be sustained by other concrete actions. For example, the action of *approach*, of measuring distances and *walking towards*. This will lead to collaborations which deny discontinuity. The act of resistance means not only

refusing to accept the absurdity of the world-picture offered us, but denouncing it. And when hell is denounced from within, it ceases to be hell.

In pockets of resistance as they exist today, the other two panels of Bosch's triptych, showing Adam and Eve and the Garden of Earthly Delights, can be studied by torchlight in the dark . . . we need them.

I would like to quote again the Argentinian poet, Juan Gelman.*

> death itself has come with its documentation/
> we're going to take up again
> the struggle/again we're going to begin
> again we're going to begin all of us
>
> against the great defeat of the world/
> little *compañeros* who never end/or
> who burn like fire in the memory
> again/and again/and again.

* Juan Gelman, *Unthinkable Tenderness,* translated from the Spanish by Joan Lindgren (University of California Press, 1997).

23

Correspondence with Subcomandante Marcos

I The Herons

Spring is the awaited season. Some languages, like
Spanish, make spring feminine; others, like Greek,
masculine. Once arrived, the two of them stay for a
weekend, hand over to a successor, and slip away.

Yet from January onwards we gossip about them as
though they were there in hiding. And under the earth's
skin they are there: the branches of elders already suffer
burgeoning wounds, snowdrops already push with their
heads, teeth clenched. When at last spring comes out
into the open we have the impression of 'no sooner
come than gone'.

Not a season at all but a longing. At my age it is natural
to ask: how many more times shall I witness this waiting?
The waiting is for a new beginning. It is not a question of
the year being young but of the offer of choices again. In
the winter of discontent, there are no choices.

The first season comes desperately and hopefully
which is another reason for its necessary clandestinity.
And here I think of your letter, Marcos, where you write:

We would like to offer you a flower, I say *a* flower
because we don't have enough for all of you, but one

is enough if you share it and if each one of you keeps a tiny fragment so that when you are old you can tell the children of your country: At the end of the twentieth century I fought for Mexico and from here I gave support to those over there: of whom I knew only that they wanted what all human beings want if they haven't forgotten that they're human beings, that's to say democracy, liberty and justice. I never saw their faces but their hearts were like ours.

This year spring came out into the open on April 12th and I'll tell you how. Your mountains are higher than ours but when you take one of the tracks down to the plain, you must come upon a somewhat similar place. At a certain altitude a rocky stream runs into a small lake and the vegetation turns a little greener. The lake seeps into the earth which is waterlogged and is difficult to cross. It's easier to skirt round the place.

In a month's time, thousands of frogs will come to mate in the pool. At the moment it still freezes at night and in the morning some of the boulders glisten with frost. Over the years I've often seen a heron here. Sometimes he is perched near the top of one of the spruce firs. Sometimes he is standing in the marsh, his fishing beak at the ready. When a heron strikes, he does so with a rapidity which is faster than an eye blinking, and after a heron has prepared a nest and is calling for a female companion, he holds his head so that his beak points vertically into the sky like a steeple or like a

Brancusi sculpture. Every winter the herons migrate from our rivers to North Africa.

Yet every year it is the same heron who returns here. Herons can live for twenty years or more. I guess this one is no longer young and maybe that is why he is a loner who avoids the settlements where the others nest. I've never seen him with his companion but I've seen him flying regularly to a hidden nest to regurgitate the frog or fish he has just eaten as food for his fledglings.

Apart from the heron, there's nothing special about the place: a pool of water, a small bog, a steepish slope. It's on the north side of the mountain and so gets little sunlight. One of nature's backyards, not recommended for its flowers. And here, on Wednesday April 12th this year, spring came out into the open.

I didn't notice anything special at first. Then gradually I became aware, before I looked up, that something unusual was happening in the sky. Nothing alarming. Rather something measured and solemn. So I glanced up.

There were two herons circling with slow wing-beats. They were low enough for me to see the black feathers like ribbons which trail from their ears. Grey wings, white throats. Whilst they flew around me one of them crossed the circle to be nearer to the other, and the other flew to meet the first, and like this both found themselves again on opposite sides of the same circle.

It was their first morning. They had come back. Ornithologists say that the male heron searches for a

partner only after he has established a nest. In which case this pair was an exception. They were cautiously surveying the terrain together.

Yet what caught my breath, Marcos, was the leisure, the ease with which they were doing this. In that leisure there was a momentary yet supreme confidence and sense of belonging. Slowly they circled the place as if they were surveying their own lives to which they had come home.

And this made me think of you in Chiapas and of your struggle to restore what has been stolen from the people by those who in this life know two things: how to transfer money and how to drop bombs. In their world there are no homecomings and there never will be. Four things came together in my head: the spring, the resistance of the Zapatistas, your vision of a different world and the slow beat of the herons' wings.

II The Herons and Eagles

A reader may ask: What is the writer's relationship
with the place and the people he writes about?

John Berger, *Pig Earth*

Agreed, but he could also ask himself: What is the
relationship between a letter written in the jungle of
Chiapas, Mexico and the response that it receives from
the French countryside? Or, even better, what is the
relationship between the slow beating of the wings of
the heron with the hovering of the eagle over a
serpent?

For example, in Guadalupe Tepeyac (now a village
empty of civilians and filled with soldiers), the herons
took over the night sky of December.

There were hundreds. 'Thousands,' says Lieutenant
Ricardo, a Tzeltal insurgent who sometimes has a pro-
pensity to exaggerate. 'Millions,' said Gladys who, de-
spite being twelve years old (or precisely because of it),
does not want to be left out. 'They come every year,' says
the grandfather while the small flashes of white hover
above the village, and maybe disappear towards the east?

Are they coming or going? Are they your herons, Mr

Berger? A winged reminder? Or a greeting filled with premonition? A fluttering of wings of something that resists death?

Because as a result, months later, I read your letter (in a dog-eared clipping from a newspaper, with the date hidden under a mud stain), and in it (your letter) the wings of dawn are hovering once again in the sky and the people of Guadalupe Tepeyac now live in the mountain and not in the little valley whose lights, I imagine, are of some significance on the navigation maps of the herons.

Yes, I know now that the herons, about which you wrote to me, fly during the winter from North Africa, and that it is improbable that they have anything to do with those that arrived in December 1994 in the Lacandon jungle. In addition the grandfather says that every year the disconcerting tour above Guadalupe Tepeyac is repeated.

Perhaps south-eastern Mexico is an obligatory stop-over, a necessity, a commitment. Perhaps they were not herons, but fragments of an exploded moon, pulverised in the December of the jungle.

December 1994

Months later, the indigenous of south-eastern Mexico again reiterated their rebellion, their resistance to genocide, to death . . . The reason?

The supreme government decided to carry out organised crime, the essence of neoliberalism, that money, the god of modernity, had planned. Dozens of thou-

sands of soldiers, hundreds of tons of war materials, millions of lies. The objective? The destruction of libraries and hospitals, of homes and seeded fields of corn and beans, the annihilation of every sign of rebellion. The indigenous Zapatistas resisted, they retreated to the mountains and they began an exodus that today, even as I write these lines, has not ended. Neoliberalism disguises itself as the defence of a sovereignty which has been sold in dollars on the international market.

Neoliberalism, this doctrine that makes it possible for stupidity and cynicism to govern in diverse parts of the earth, does not allow for inclusion other than that of subjection to genocide. 'Die as a social group, as a culture, and above all as a resistance. Then you can be part of modernity,' say the great capitalists, from the seats of government, to the indigenous *campesinos*. These indigenous people irritate the modernising logic of neomercantilism. Their rebellion, their defiance, their resistance, irritates them. The anachronism of their existence within a project of globalisation, an economic and political project that, soon, will decide that poor people, all the people in opposition, which is to say, the majority of the population, are obstacles. The armed character of 'We are here!' of the Zapatista indigenous people does not matter much to them nor does it keep them awake (a little fire and lead will be enough to end such 'imprudent' defiance). What matters to them, and bothers them, is that their very existence, in the moment that they (the indigenous Zapatistas) speak out and are

heard, is converted into a reminder of an embarrassing omission of 'neoliberal modernity': 'These Indians should not exist today, we should have put an end to them BEFORE. Now annihilating them will be more difficult, which is to say, more expensive.' This is the burden that weighs upon neoliberalism made government in Mexico.

'Let's resolve the causes of the uprising,' say the negotiators of the government (leftists of yesterday, the shamed of today) as if they were saying: 'All of you should not exist, all this is an unfortunate error of modern history.' 'Let's resolve the causes' is the elegant synonym of 'We will eliminate them'. For this system which concentrates wealth and power and distributes death and poverty, the *campesinos*, the indigenous, do not fit in the plans and projects. They have to be got rid of, just like the herons . . . and the eagles . . . have to be got rid of.

What remains mysterious is not so much what has been deliberately hidden but, as I have said, the surprising range of the possible. And thus, too, there is little performing: peasants do not *play roles* as urban characters do. This is not because they are 'simple' or more honest or without guile, it is simply because the space between what is unknown about a person and what is generally known – and this is the space for all performance – is too small.

<div align="right">John Berger, ibid.</div>

December 1994

A cold dawn that drags itself between the fog and the thatched roofs of the village. It is morning. The dawn goes away, the cold remains. The little paths of mud begin to fill with people and animals. The cold and a little footpath accompany me in the reading of *Pig Earth*. Heriberto and Eva (five and six years old respectively) come and grab ('they snatched' I should say, but I don't know if the distinction is understood in English) the book. They look at the drawing on the front cover (it is a Madrid edition from 1989). It is a copy of a painting by John Constable, an image of an English countryside. The cover of your book, Mr Berger, summons a rapid connection between image and reality. For Heriberto, for example, there is no doubt that the horse in the painting is La Muñeca (The Doll) (a mare that accompanied us in the long year during which the indigenous rebellion governed south-eastern Mexico), whom no one could mount except Manuel, a playmate who was twice the age, size and weight of Heriberto, who was Chelita's brother, and consequently, also his future brother-in-law. And what Constable called 'a river' was really a riverbed, a riverbed that crossed through La Realidad (La Realidad is the name of a village), a reality which is the limit of Heriberto's horizons. The furthest place that his trips and running around have taken him is *la realidad*.

Constable's painting did not remind Heriberto and Eva of the English countryside. It did not take them

outside of the Lacandon jungle. It left them there, or it brought them back. It brought them back to their land, their place, to their being children, to their being *campesinos*, to their being indigenous, to their being Mexicans and rebels. For Heriberto and Eva, Constable's painting is a coloured drawing of La Muñeca and the title, *Scene on a Navigable River*, is not a valid argument: the river is the riverbed of La Realidad, the horse is the mare La Muñeca, Manuel is riding, and his sombrero fell off, and that's it, on to another book. And we do that, this time it is about Van Gogh and for Eva and Heriberto, the paintings of Holland are scenes from their land, of their being indigenous and *campesinos*. After this Heriberto tells his mother that he spent the morning with the Subcomandante.

'Reading big books,' says Heriberto, and I believed that this earned him a free hand with a box of chocolate cookies. Eva was more far-sighted, and asked me if I didn't have a book about her doll with the little red bandanna.

> The act of writing is nothing except the act of approaching the experience written about; just as, hopefully, the act of reading the written text is a comparable act of approach.
>
> John Berger, ibid.

Or of distancing, Mr Berger. The writing, and above all, the reading of the written text could be an act of

distancing. 'The written word and the image,' says my other, which to add problems paints himself, alone.

I think that yes, that the 'reading' of the written word and the image could approximate the experience or distance it. And so, the photographic image of Alvaro, one of the dead combatants in Ocosingo in January 1994, returns. Alvaro returns in the photo. Alvaro with his death speaks in the photo. He says, he writes, he shows: 'I am Alvaro, I am an indigenous, I am a soldier, I took up arms against being forgotten. Look. Listen. Something is happening in the closing of the twentieth century that is forcing us to die in order to have a voice, to be seen, to live.' And from the photo of Alvaro dead, a far-off reader from the distance could approximate the indigenous situation in modern Mexico, NAFTA, the international forums, the economic bonanza, the first world.

'Pay attention! Something is evil in the macroeconomic plans, something is not functioning in the complicated mathematical calculations that sing the successes of neoliberalism,' says Alvaro with his death. His photo says more, his death speaks, his body on the soil of Chiapas takes voice, his head resting in a pool of blood: 'Look! This is what the numbers and the speeches hide. Blood, cadavers, bones, lives and hopes, crushed, squeezed dry, eliminated in order to be incorporated into the indices of profit and economic growth.'

'Come!' says Alvaro. 'Come close! Listen!'

But Alvaro's photo also can 'be read' from a distance, as a vehicle that serves to create distance in order to stay on the other side of the photo, like 'reading' it in a newspaper in another part of the world. 'This did not happen here,' says the reader of the photo, 'this is Chiapas, Mexico, a historical accident, remedial, forgettable, and . . . far away.' There are, in addition, other readers who confirm it: public announcements, economic figures, stability, peace. This is the use of the indigenous war at the end of the century, to revalue 'peace'.

Like a stain stands out on the object that is stained. 'I am here and this photo happened over there, far away, small,' says the 'reader' who distances himself.

And I imagine, Mr Berger, that the final result of the relationship between the writer and the reader, through the text ('or from the image', insists my other self again), escapes both. Something is imposed on them, gives significance to the text, provokes one to come closer or go further away. And this 'something' is related to the new division of the world, with the democratisation of death and misery, with the dictatorship of power and money, with the regionalisation of pain and despair, with the internationalisation of arrogance and the market. But it also has to do with the decision of Alvaro (and of thousands of indigenous along with him) to take up arms, to fight, to resist, to seize a voice that they were denied before, not to devalue the cost of the blood that this implies. And it also has to do with the ear and eye

that are opened by Alvaro's message, whether they see and hear it, whether they understand it, whether they draw near to him, his death, his blood that flooded the streets of a city that has always ignored him, always . . . until this past January the first. It also has to do with the eagle and heron, the European *campesino* who is resisting being absorbed and the Latin American indigenous who is rebelling against genocide. It has to do with the panic of the powerful, as the trembling, that is growing in its guts, no matter how strong and powerful it appears, when, without knowing, it prepares to fall . . .

And it has to do with, I reiterate and salute it in this way, the letters that come from you to us, and those that, with these lines, bring you these words: the eagle received the message, he understood the approach of the hesitant flight of the heron. And there below, the serpent trembles and fears the morning . . .

Vale, Mr Berger. Health and follow closely the heron up above until it appears as a small and passing flash of light, a flower that lifts itself up . . .

From the mountains of southern Mexico
Subcomandante Insurgente Marcos
Mexico, May 1995

III How to Live with Stones

Marcos, I want to say something about a pocket of resistance. One particular one. My observations may seem remote, but, as you say, 'A world can contain many worlds, can contain all worlds.'

The least dogmatic of our century's thinkers about revolution was Antonio Gramsci, no? His lack of dogmatism came from a kind of patience. This patience had absolutely nothing to do with indolence or complacency. (The fact that his major work was written in the prison in which the Italian fascists kept him for eight years, until he was dying at the age of forty-six, testifies to its urgency.)

His special patience came from a sense of a practice which will never end. He saw close-up, and sometimes directed the political struggles of his time, but he never forgot the background of an unfolding drama whose span covers incalculable ages. It was perhaps this which prevented Gramsci becoming, like many other revolutionaries, a millennialist. He believed in hope rather than promises and hope is a long affair. We can hear it in his words:

If we think about it, we see that in asking the question: What is Man? we want to ask: What can man become? Which means: Can he master his own destiny, can he make himself, can he give form to his own life? Let us say then that man is a process, and precisely, the process of his own acts.

Gramsci went to school, from the age of six until twelve, in the small town of Ghilarza in central Sardinia. He was born in Ales, a village nearby. When he was four he fell to the floor as he was being carried, and this accident led to a spinal malformation which permanently undermined his health. He did not leave Sardinia until he was twenty. I believe the island gave him or inspired in him his special sense of time.

In the hinterland around Ghilarza, as in many parts of the island, the thing you feel most strongly is the presence of the stones. First and foremost it is a place of stones, and – in the sky above – of grey hooded crows. Every *tanca* – pasture – and every cork-oak plantation has at least one, often several piles of stones and each pile is the size of a large freight truck. These stones have been gathered and stacked together recently so that the soil, dry and poor as it is, can nevertheless be worked. The stones are large, the smallest would weigh half a ton. There are granites (red and black), schist, limestone, sandstone and several darkish volcanic rocks like basalt. In certain *tancas* the gathered boulders are long rather than round, so they have been piled together like poles

and the pile has a triangular shape like that of an immense stone wigwam.

Endless and ageless dry-stone walls separate the *tancas*, border the gravel roads, enclose pens for the sheep, or, having fallen apart after centuries of use, suggest ruined labyrinths. There are also little pyramid piles of smaller stones no larger than fists. Towards the west rise very ancient limestone mountains.

Everywhere a stone is touching a stone. And here, over this pitiless ground, one approaches something delicate: there is a way of placing one stone on another which irrefutably announces a human act, as distinct from a natural hazard.

And this may make one remember that to mark a place with a cairn constituted a kind of naming and was probably among the first signs used by man.

Knowledge is power [wrote Gramsci], but the question is complicated by something else: namely that it is not enough to know a set of relations existing at a given moment as if they were a given system, one also needs to know them genetically – that's to say the story of their formation, because every individual is not only a synthesis of existing relations, but also the history of those relations, which means the résumé of all the past.

On account of its strategic position in the western Mediterranean and on account of its mineral deposits

– lead, zinc, tin, silver – Sardinia has been invaded and its coastline occupied during four millennia. The first invaders were the Phoenicians, followed by the Carthaginians, the Greeks, the Romans, the Arabs, the Pisans, the Spanish, the House of Savoy and finally modern mainland Italy.

As a result Sardinians mistrust and dislike the sea. 'Whoever comes across the sea,' they say, 'is a thief.' They are not a nation of sailors or fishermen, but of shepherds. They have always sought shelter in the stony inaccessible interior of their land to become what the invaders called (and call) 'brigands'. The island is not large (250 km. × 100 km.) yet the iridescent mountains, the southern light, the lizard-dryness, the ravines, the corrugated stony terrain, lend it, when surveyed from a vantage point, the aspect of a continent! And on this continent today, with their 3.5 million sheep and their goats, live 35,000 shepherds: 100,000 if one includes the families who work with them.

It is a megalithic country – not in the sense of being prehistoric – like every poor land in the world it has its own history ignored or dismissed as 'savage' by the metropols – but in the sense that its soul is rock and its mother stone. Sebastiano Satta (1867–1914), the national poet, wrote:

When the rising sun, Sardinia, warms your granite
You must give birth to new sons.

This has gone on, with many changes but a certain continuity, for six millennia. The shepherd's pipe of classical mythology is still being played. Scattered over the island there remain 7,000 *nuraghi* – dry-stone towers, dating from the late neolithic period before the Phoenician invasion. Many are more or less ruins; others are intact and may be 12m. in height, 8m. in diameter, with walls 3m. thick.

It takes time for your eyes to get used to the dark inside one. The single entrance, with a hewn architrave, is narrow and low; you have to crouch to get in. When you can see in the cool dark inside, you observe how, to achieve a vaulted interior without mortar, the layers of massive stones had to be laid one on top of the other with an overlap inwards, so that the space is conical like that of a straw beehive. The cone, however, cannot be too pointed, for the walls need to bear the weight of the enormous flat stones which close the roof. Some *nuraghi* consist of two floors with a staircase. Unlike the pyramids, a thousand years earlier, these buildings were for the living. There are various theories about their exact function. What is clear is that they offered shelter, probably many layers of shelter, for men are many-layered.

The *nuraghi* are invariably placed at a nodal point in the rocky landscape, at a point where the land itself might, as it were, have an eye: a point from which everything can be silently observed in every direction – until, faraway, the surveillance is handed on to the next *nuraghi*. This suggests that they had, amongst other things, a military,

defensive function. They have also been called 'sun temples', 'towers of silence' and, by the Greeks, '*daidaleia*' after Daedalus, the builder of the labyrinth.

Inside, you slowly become aware of the silence. Outside there are blackberries, very small and sweet ones, cacti whose fruit with stony pips the shepherds take the thorns out of and eat, hedges of bramble, barbed-wire, asphodels like swords whose hilts have been planted in the thin soil . . . perhaps a flock of chattering linnets. Inside the hive of stones (constructed before the Trojan Wars) silence. A concentrated silence – like tomato purée concentrated in a tin.

By contrast, all extensive diffused silence has to be continually monitored in case there is a sound that warns of danger. In this concentrated silence the senses have the impression that the silence is a protection. Thus you become aware of the companionship of stone.

The epithets 'inorganic', 'inert', 'lifeless', 'blind' – as applied to stone – may be short-term. Above the town of Galtelli towers the pale limestone mountain which is called Monte Tuttavista – the mountain which sees all.

Perhaps the proverbial nature of stone changed when pre-history became history. Building became rectangular. Mortar permitted the construction of pure arches. A seemingly permanent order was established, and with this order came talk of happiness. The art of architecture quotes this talk in many different ways, yet for most people the promised happiness did not arrive, and the proverbial reproaches began: stone was contrasted with

bread because it was not edible, stone was called heartless because it was deaf.

Before, when any order was always shifting and the *only* promise was that contained in a place of shelter, in the time of the *nuraghis*, stones were considered as companions.

Stones propose another sense of time, whereby the past, the deep past of the planet, proffers a meagre yet massive support to human acts of resistance, as if the veins of metal in rock led to our veins of blood.

To place a stone upright so that it stands vertical is an act of symbolic recognition: the stone becomes a presence; a dialogue begins. Near the town of Macomer there are six such standing stones summarily carved into ogival forms; three of them, at shoulder-level, have carved breasts. The sculpting is minimal. Not necessarily through lack of means; perhaps through choice. An upright stone then did not depict a companion: it was one. The six bethels are of trachytic rock which is porous. As a result, even under a strong sun, they reach body heat and no more.

When the rising sun, Sardinia, warms your granite
You must give birth to new sons.

Earlier than the *nuraghi* are the *domus de janas*, which are rooms hollowed out of rock-pediments, and made, it is said, to house the dead.

This one is made of granite. You have to crawl in, and

inside you can sit but not stand. The chamber measures 3 m. by 2. Stuck to its stone are two deserted wasp nests. The silence is less concentrated than in the *nuraghi* and there is more light, for you are less deeply inside; the pocket is nearer to the outside of the coat.

Here the age of the man-made place is palpable. Not because you calculate . . . mid-neolithic . . . calcolithic, but because of the relation between the rock you are in and human touch.

The granite surface has been made deliberately smooth. Nothing rough or jagged has been left. The tools used were probably of obsidian. The space is corporeal – in that it seems to pulse like an organ in a body. (A little like a kangaroo's pocket!) And this effect is increased by the remaining soft smears of yellow and reddish ochre where originally the surfaces were painted. The irregularities of the chamber's shape must have been determined by variations in the rock formation. But more interesting than where they came from is where they are heading.

You lie in this hiding place, Marcos – there is a faint sweetish almost vanilla smell coming from some herb outside – and you can see in the irregularities the first probings towards the form of a column, the outline of a pilaster or the curves of a cupola – towards the idea of happiness.

By the foot of the chamber – and there's no question which way the bodies, either alive or dead, were intended to lie – the rock is curved and concave and on

this surface a human hand has chipped distinct radiating ribs as on a scallop shell.

By the entrance, which is no higher than a small dog, there was a protrusion like a fold in the rock's natural curtain, and here a human hand tapered and rounded it so that it approached – but did not yet reach – the column.

All *domus de janas* face east. Through the entrances from the inside you can see the sun rise.

In a letter from prison in 1931 Gramsci told a story for his two children, the younger of whom, because of his imprisonment, he had never seen. A small boy is asleep with a glass of milk beside his bed on the floor. A mouse drinks the milk, the boy wakes up and finding the glass empty cries. So the mouse goes to the goat to ask for some milk. The goat has no milk, he needs grass. The mouse goes to the field, and the field has no grass because it's too parched. The mouse goes to the well and the well has no water because it needs repairing. So the mouse goes to the mason who hasn't exactly the right stones. Then the mouse goes to the mountain and the mountain wants to hear nothing and looks like a skeleton because it has lost its trees. (During the last century Sardinia was drastically deforested to supply railway sleepers for the Italian mainland.) In exchange for your stones, the mouse says to the mountain, the boy, when he grows up, will plant chestnuts and pines on your slopes. Whereupon the mountain agrees to give the stones. Later the boy has so much milk, he washes in it!

Later still, when he becomes a man, he plants the trees, the erosion stops and the land becomes fertile.

P.S. In the town of Ghilarza there is a small Gramsci Museum, near the school he attended. Photos. Copies of books. A few letters. And, in a glass case, two stones carved into round weights about the size of grapefruits. Every day Antonio as a boy did lifting exercises with these stones to strengthen his shoulders and correct the malformation of his back.

24

Will It Be a Likeness?

(for Juan Munoz)

Good Evening. Last week I talked about the dog and we listened to some dogs barking. I suggested that this noise after the aeons of dogs' association with man had something to do with spoken language. Something, but what exactly?

A number of listeners have written me letters – for which I thank you – all of them about the way in which dogs communicate. Some of you sent photos to illustrate your experience.

I gave you my opinion last week that the dog is the only animal with an historical sense of time, but that he can never be an historical agent. He suffers history but he can never make it. And then we looked together at the famous painting by Goya on the subject. And we decided it was better to look at paintings on the radio than on the television. On the TV screen nothing is ever still, and this movement stops painting being painting. Whereas on the radio we see nothing, but we can listen to silence. And every painting has its own silence.

A listener from the Black Forest has written to ask whether, after the dog, we might consider the butterfly, and in particular the *Anthocaris Cardamines*, commonly known as the Fiancée. For this listener – although our

principal subject this evening is something altogether different – we have recorded here in the studio the Fiancée in flight. And if you shut the windows and settle in your chair you will now hear the wings of the *Anthocaris Cardamines* beating in flight.

Every butterfly too has its own special silence. For sometimes a sound is more easily grasped as a silence, just as a presence, a visible presence, is sometimes most eloquently conveyed by a disappearance.

Who does not know what it is like to go with a friend to a railway station and then to watch the train take them away? As you walk along the platform back into the city, the person who has just gone is often more there, more totally there, than when you embraced them before they climbed into the train. When we embrace to say goodbye, maybe we do it for this reason – to take into our arms what we want to keep when they've gone.

Excuse me, the telephone has just rung. You can't hear it, can you? A listener asks what century in God's name do I think I'm living in? Sounds like the nineteenth, he told me.

No, sir, the one I live in is the sixteenth or the ninth. How many, sir, do you think are not dark? One in seven?

Today everything everywhere on the planet is for sale.

I'm selling. Here's a back, a man's working back, not yet broken. Did I hear an offer?

What's a back for?
To sell wherever they need cheap backs for work.
Bought!

Every evening Goya takes his dog for a walk along the Ramblas.

A heart?
How come?
Sixteen and healthy from Mexico.
OK. Taken!

Then man and dog stroll home and Goya draws the curtains and settles down to look at CNN.

A kidney.
Bought!
One male member and a uterus together.
Together how?
They stayed together. They were chased out of their village, they had no land and they were obliged to sell everything to survive.
I'll take the uterus.
And the male member?
Throw it away, plenty more where it came from.
Difficult – they're inseparable.
NAFTA! Separate them!
I'm not sure how.
NAFTA! I tell you!

Nafta?
North American Free Trade Agreement.

No sir, I live in this century which I can't say is ours. And now, if I may, I shall return to the mystery of what makes a presence.

When all the members have been separated and all the parts sold, what is left?
Something more to sell. A whole is more than the sum of its parts, so we sell the personality. A personality is a media-product and easy to sell. A presence is the same thing as personality, no?
Presence is not for sale.
If that's true, it's the only thing on this earth which isn't.
A presence has to be given, not bought.

Three hundred girls from Thailand.
I'll take them. Ask Melbourne if he's still interested.

A presence is always unexpected. However familiar. You don't see it coming, it moves in sideways. In this a presence resembles a ghost or a crab.

He's let the dog out and the master has gone to sleep.

Once I was in a train travelling to Amsterdam, through Germany, going north following the Rhine. It was a

Sunday and I was alone in the compartment and had been travelling for several hours. With me I had a cassette player and so I decided to listen to some music. Beethoven's one-from-last piano sonata. A man stops in the corridor and peers into the compartment. He makes a sign with his hands to enquire if he can open the door. I slide the door open. Come in, I say. He puts a finger to his lips, sits down and slides the door shut. We listen. When the sonata ends, there's only the noise of the train . . . He's a man of about my age but better dressed and with an attaché case. From it he takes out a sheet of paper, writes some words on it and hands the paper to me. 'Thank you,' I read, 'for allowing me to listen with you.' I smile, nod and know that I should not speak. We sit there silently in the presence of the last movement of the sonata. This is how a presence makes itself felt.

An hour later when a vendor came down the corridor selling coffee and sandwiches, my travelling companion pointed to what he wanted and I understood that he was dumb, that he could not speak.

Excuse me, the telephone again. A listener wants to know: Who was the pianist?

Piotr Anderszewski.

That's not true. Why do you lie?

Because Piotr is a friend of mine. He plays marvellously, sometimes he plays with his sister, Dorothea, who is a violinist, he comes from Poland, he's poor and he's already twenty-six and soon – such is the competition on the concert circuit – soon it will be too late, for ever too

late, for him to be recognised for the great pianist he is. So I lied to help him. Piotr. If I keep quiet, I can hear him playing the Diabelli Variations.

On my way here to the radio station this evening I passed a photography shop. In their window they have a notice that says: IDENTITY PHOTOS WITH A TRUE LIKE-NESS – READY IN TEN MINUTES!

To talk of a likeness is another way of talking of a presence. With photos the question of likeness is inci-dental. It's merely a question of choosing the likeness you prefer. With a painted or drawn portrait likeness is fundamental; if it's not there, there's an absence, a gaping absence.

The dog is now asking to be let in. The master gets up, opens the door and, instead of returning to bed, goes to his easel on which there is an unfinished painting.

You can't hunt for a likeness. It can escape even a Raphael . . . Strangely, you can tell whether a likeness is there or not when you've never set eyes on the model or seen any other image of the model. For example, in Raphael's portrait of a woman known as La Mata, the dumb one, there is an astounding likeness. *You can hear it.*

By contrast, in Raphael's double portrait of himself and a friend, painted in 1517, there's no likeness present at all. This time it's a silence without any life in it. Enough

to compare this silence with the Fiancée beating her wings, for us to feel the gaping absence.

There's a village. A Kurdish mountain village in Eastern Anatolia. One night a wolf comes and kills many chickens and ravishes a lamb. Next morning everyone leaves the village, the men with rifles, the women with dogs and the children with sticks. It is not the first time this has happened and they know what to do. They are going to encircle the wolf. Slowly the circle closes, getting smaller, with the wolf in the middle. Finally it's no larger than a small room. The dogs are growling. The men are holding their ropes and rifles and the end is very near. So what do they do? Wait! They slip a cord over the wolf's neck and attached to the cord is a bell! Then they disperse and let the wolf go free . . .

You can't set out to trap a likeness. It comes on its own or it doesn't, a likeness. It moves in sideways.

Are you saying a likeness can't be bought or sold?

No, it can't.

Bad news. Maybe you are lying again?

This time there's no need to lie.

Wolves! Bells! Things which move in sideways! Pure mystification! What you can't, in principle, buy or sell, doesn't exist! This is what we now know for certain. What you're talking about is your personal phantasm – to which of course you have every right. Without phantasms there would be no consumers, and we'd be back with the apes.

* * *

Animals are capable of feeling a presence. When a dog recognises a garment of his master by its smell – he perceives something similar to a likeness.

You are obsessed with dogs! I thought we were thinking about invention, creation, human wealth.

One female thyroid gland!

Don't! A single thyroid is not sellable. If you're offered one, it's suspect.

There's a painting from Pompeii I'd like to send you by radio.

Of a dog, I suppose.

No, a woman. She's holding a wooden tablet, like a book, in her left hand, and in her right, a pen or stylo, the end of which she holds against her lip. She's thinking about words not yet written. The portrait was painted in the year 79 – the year in which the town was buried – and preserved – in lava. Probably the words were never written.

Not a great painting, and if I'm sending it to you – it's simply because it's a likeness. She's here in the studio in front of me, with her fringe just out of curlers, and her earrings of gold, which, as soon as she puts them on, are never still.

A likeness is a gift, something left behind and hidden and later discovered when the house is empty . . . Whilst hidden, it avoids time.

What do you mean 'avoids time'?

Confuses time, if you prefer.

You wouldn't get away with this nonsense on television! TV demands speed and clarity. You can't ramble across the screen as you're rambling now.

So I send you the Pompeian woman of two millennia ago, with the tip of her stylo lightly touching her lower lip and her hands which are not rough with work and never will be. At the most she's twenty years old, and you have the impression of having just seen her. Her earrings tinkling.

You are a nostalgic old man!

Or a young romantic?

Anyway they're both finished, they belong to the past. Today we live in a world of exchanges, calculations at the speed of light, credits, debts and winnings.

And the dead don't exist?

Let the dead bury the dead – that was well said and has always been true.

Our plan is more kilos for less cost.

> The cattle feed
> is driving the cows mad
> their guts were created
> for grasses
> not for offal.

More and more kilos for less and less cost.

The madness may be transmittable!

Keep quiet and do not forget: the meat of the future is profit.

I still have a portrait I painted when I was twenty. It's of a woman asleep in a chair and on the table in front of her, in the foreground, there is a bowl of flowers. I was in love with the woman and we lived together in two small rooms on the ground floor in a house in London. I think somebody today could tell from the painting that I loved her, but there's no likeness there. Her primrose green dress – she made it herself on the table in the room where I painted – has a distinct presence, and her fair hair, in whose colour I always saw green, is striking. But there's no likeness. And until six months ago, if I looked at the painting, I couldn't refind a likeness in my memory either. If I shut my eyes, I saw her. But I couldn't see her sitting in the chair in her green dress.

Six months ago I happened to be in London and I found myself two minutes' walk away from the modest house where we rented the two rooms. The house had been done up and repainted but it hadn't been rebuilt. So I knocked on the door. A man opened it and I explained that fifty years ago I had lived there and would it be possible for me to see the two rooms on the ground floor?

He invited me in. He and his wife occupied the whole house. There were carpets and lamps and paintings and china plates on the walls and a hi-fi and silver trays. Useless to look for the gas meter which we fed with coins when we

were cold and needed to light the gas-fire or heat some water. Useless to look for the bathtub, which, when we weren't taking a bath together, served as a support for a tabletop on which we chopped onions and beat eggs for an omelette. Everything had been replaced and nothing was the same except for the plaster mouldings on the ceiling and the proportions of the large window by whose light she made her clothes and I painted.

I asked if I could draw back the curtains. And I stood there staring at the window panes – it was raining and already evening so I could see nothing outside.

And standing there, I found her likeness, as she sat in the chair in her green dress, asleep.

Likenesses hide in rooms, you find them sometimes when the rooms are being emptied.

There are certain people who are so secluded – they live in a kind of Switzerland of perception – that they can't see a likeness when it's staring them in the face.

A journalist is visiting a modern prison of which the local authorities are proud. They call it a model prison. He is chatting with a long-term prisoner. Finally, still taking notes, the journalist asks: And what did you do before? Before what? Before you were here? The prisoner stares at him. Crime, he says, crime . . .

Talking of model prisons, a new women's prison has just been built in Britain. Each cell measures 3 steps by 3 steps. A zoo director commented on the smallness of the

space. 'No zoo would confine an ape in an area measuring this. It would damage both the psychological and the physical well-being of the animal. It would not be allowed in any professional zoo.' A third of the women prisoners in Britain are there for not paying fines or TV licences.

Arno Schmidt in one of his books quotes from a poem in English:

> I go towards my likeness, and my likeness goes towards
> me.
> She embraces me and holds me close, as if I had come
> out of prison.

It is a new day, and Goya is taking the dog for a walk. They are both in exile. In the town of Bordeaux which, when there is a west wind, smells of the Atlantic.

As the Nikkei Stock Average breaks through the 2,000-point mark, European money managers brim with confidence that the market to watch next year will be Japan.

An eye with a perfect retina, going, going, gone!

'In these parts it is a miracle the people are still alive,' said Moisés, a young man who joined the Zapatista insurrection in south-east Mexico. 'Families of seven

to twelve people have been surviving on a hectare or half a hectare of infertile soil . . . We have nothing, absolutely nothing, no decent roof over our heads, no land, no work, no health, no food, no education . . .' The year was 1994.

Now I'm going to send you by radio a strange likeness – that of a man whose face we do not know. Whenever he's in company, he wears a black ski mask. 'Here we are,' he says, 'the forever dead, dying once again, but now in order to live.' His assumed name is Marcos.

A terrorist! It was agreed that this was a radio talk about economics, and you contrive to introduce a terrorist. An expert in violence!

I'm transmitting his likeness. A likeness created by his own words:

I have the urge to write to you and tell you something about being 'the professionals of violence', as we have so often been called. Yes, we are professionals. But our profession is hope . . . out of our spent and broken bodies must rise up a new world . . . Will we see it? Does it matter? I believe that it doesn't matter as much as knowing with undeniable certainty that it will be born, and that we have put our all – our lives, bodies and souls – into this long and painful but historic birth. *Amor y dolor* – love and pain: two words that not only rhyme, but join up and march together.

Empty leftist rhetoric!

Here is the rest of the likeness:

> There is something else about this passionate moving of words, something that does not appear in any postscript or any communiqué. It is the anxiety, the uncertainty, the galloping questions that assault us every time one of the couriers leaves with one, or several, communiqués. Questions and more questions fill up our nights, accompany us on our rounds to check the guards, sit beside us on some broken tree trunk looking at the food on the plate . . . 'Were these words the best ones to say what we wanted to say?' 'Were they the right words at this time?' 'Were they understandable?'

A likeness is a gift and remains unmistakable – even when hidden behind a mask.

A likeness can be effaced. Today Che Guevara sells T-shirts, that's all that is left of his likeness.

Are you sure?

[Silence]

Silence, you know, is something that can't be censored. And there are circumstances in which silence becomes subversive. That's why they fill it with noise all the while.

*　　*　　*

Goya is walking with his dog by the ocean.

The other day I was listening to Glenn Gould playing Mozart's Fantasy in C Major. I want to remind you of how Gould plays. *He plays like one of the already dead come back to the world to play its music.* And that's how he played when he was alive!

Three nimble hands.
Why three?
One of the two women had an accident at work.
Bought.

I'll tell the story of the best likeness ever made. John is the only one who tells the story. The other Evangelists don't refer to it – though they refer to Martha and Mary. The two sisters had a brother, Lazarus, who fell sick and died in the village of Bethany. When Jesus, who was a friend of the family, arrived in the village, Lazarus had been dead and buried for four days.

'Where have you laid him?' he asked.

'Come and see, Lord,' they replied.

Jesus wept.

Then the Jews said: 'See how he loved him!'

But some of them said: 'Could not he, who opened the eyes of the blind man, have kept this man from dying?'

Jesus, once more deeply moved, came to the tomb. It was a cave with a stone laid across the entrance. 'Take away the stone,' he said.

So they took away the stone.

Jesus called in a loud voice, 'Lazarus, come out!' The dead man came out, his hands and feet wrapped with strips of linen and a cloth round his face.

Jesus said to them: 'Take off the grave clothes and let him go.'

This was the perfect likeness. And it provoked Caiaphas, the high priest, to lay the plot for the taking of Jesus's own life.

Goya is going back to work in his studio.

Now he is painting. Can you hear him? Faces appear on the canvas. Then they disappear. All have gone.

Try turning the volume of the silence up – higher – higher. Higher still . . .

[Total silence]

Is this the silence of a likeness, of the mountains at night in south-east Mexico, or of us listening together?

Acknowledgements

The essays in this book were first printed – sometimes with different titles and in a slightly different form – in the following publications:

1. Opening a Gate *The Russian Way (Opus 31)* by Pentti Sammallahti Photographic Portfolio, Finland, 1996
2. Steps Towards a Small Theory of the Visible *Das Abenteuer der Malerei (The Adventure of Painting)*, Editions Tertium, Ostfildern, Germany, 1995
3. Studio Talk *Miquel Barceló, Recent Paintings*, Timothy Taylor Gallery, London, 1998
4. The Chauvet Cave *Guardian*, London, 16 November 1996
5. Penelope *Tages Anzeiger*, Zurich, 18 April 1997
6. The Fayum Portraits *El Pais*, Madrid, 20 December 1998
7. Degas *Die Weltwoche*, Zurich, 29 July 1993
8. Drawing: Correspondence with Leon Kossoff *Guardian*, London, 1 June 1996
9. Vincent *Aftonbladet*, Stockholm, 20 August 2000
10. Michelangelo *Guardian*, London, 21 November 1995
11. Rembrandt and the Body *Frankfurter Rundschau*, Frankfurt, 2 May 1992

12. A Cloth Over the Mirror *Independent*, London, 3 June 2000

13. Brancusi *Die Weltwoche*, Zurich, 6 June 1995

14. The River Po *'du' Die Zeitschrift der Kultur*, Zurich, November 1995

15. Giorgio Morandi *El Pais*, Madrid, 7 February 1997

16. Pull the Other Leg, It's Got Bells On It *Guardian*, London, 3 June 1995

17. Frida Kahlo *Guardian*, London, 12 May 1998

18. A Bed *Wet Roks Seen From Above*. Paintings: Christoph Hänsli Memory/Cage Editions, Zurich, 1996

19. A Man with Tousled Hair *Le Monde Diplomatique*, Paris, December 1991

20. An Apple Orchard *Le Monde Diplomatique*, Paris, September 2000

21. Brushes Standing Up in Jars *Aftonbladet*, Stockholm, 5 April 1996

22. Against the Great Defeat of the World *Race & Class*, London, October 1998–March 1999

23. Correspondence with Subcomandante Marcos:
 I The Herons *El Pais*, Madrid, 27 April 1995
 II The Herons and Eagles *La Jornada*, Mexico City, 3 June 1995
 III How to Live with Stones *Le Monde Diplomatique*, Paris, November 1997

24. Will It Be a Likeness? First performed by John Berger at Das Tat Theater im Bockenheimer Depot, Frankfurt, 1996. Directed by Juan Munoz. Simultaneous radio broadcast: Heissischer Rundfunk, Frankfurt. BBC Radio 3, 1996. First printed *La Jornada*, Mexico City, 4 August 1996.